THE KEN FOX HELL RIDERS

A Journey with the Wall of Death

GARY MARGERUM

The History Press

'The wall of death is a fantastic spectacle.
This book gives you an insight into this extraordinary life.'

Charley Boorman

I dedicate this book to riders past and present and to Ken Fox,
his family and the team behind them.

Cover illustration: Scarlett Rickard.

First published 2012

The History Press
The Mill, Brimscombe Port
Stroud, Gloucestershire, GL5 2QG
www.thehistorypress.co.uk

© Gary Margerum, 2012

The right of Gary Margerum to be identified as the Author
of this work has been asserted in accordance with the
Copyrights, Designs and Patents Act 1988.

British Library Cataloguing in Publication Data.
A catalogue record for this book is available from the British
Library.

ISBN 978 0 7524 6573 9

Typesetting and origination by The History Press
Printed in Great Britain
Manufacturing managed by Jellyfish Print Solutions Ltd

FOREWORD

It gives me great pleasure to write the foreword to Gary Margerum's new book. Over the last two years I have witnessed the enthusiasm and passion Gary has for the Wall of Death. During the course of his time visiting our show, he has taken many images and has become more than just another photographer; he is also a friend. None of his images are posed in any way – we simply carried on with our daily tasks and allowed him free access.

All Gary's photographs are completely natural. They show not just the glamour of performing and riding the Wall of Death for the public, but they also reflect the hours spent behind the scenes, something rarely seen outside our own community. Nothing has been withheld – we have quite literally allowed him to take whatever photographs he chose. The result is a stunning collection of images reflecting all aspects of a way of life rarely seen by the public.

The Wall of Death is a big, heavy, piece of equipment and, in the wrong hands, is every bit as dangerous to build up and pull down as to ride. It requires dedication and teamwork by everyone involved and this is clearly shown in Gary's pictures. This is a book everyone can read – the photographs give you an insight into a typical season. This is not another fairground book; the collection of photographs are stunning and should be seen and enjoyed by everyone.

Neil Calladine
Spieler, The Ken Fox Wall of Death

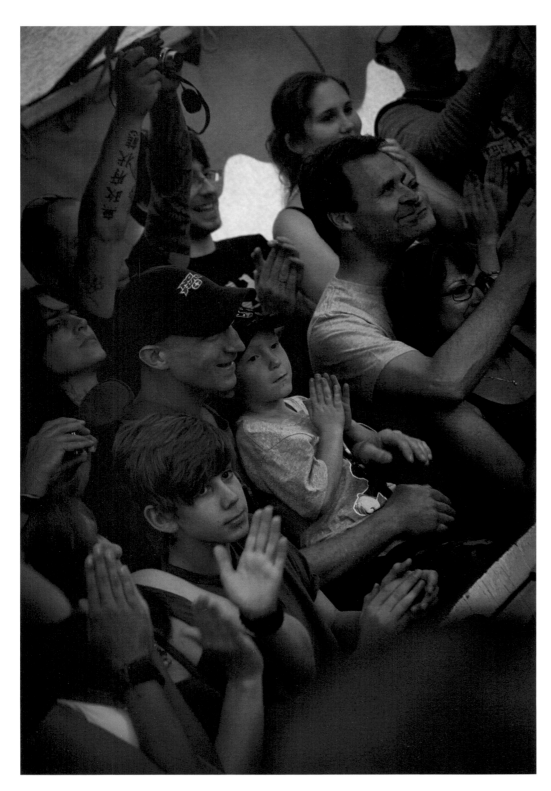

Croydon 2010.

THE WALL OF DEATH

The Wall of Death has been fascinating crowds since just after the turn of the twentieth century and arrived on English shores in the 1920s. Little has changed over the years. The riders today still challenge death with every performance and the Ken Fox troupe is no exception. Their showmanship and discipline can clearly be seen from the gallery.

The performance of Ken and his team is electrifying, the speed and agility of the riders must be seen with your own eyes to be believed. You walk up the sixteen steps, sliding your hand up the highly chromed handrail, into the viewing area. You can feel the excitement and anticipation of the crowd that surrounds the wooden cylinder as a young boy on tiptoes tries to peer over the safety wire into the arena below to catch a glimpse of one of the riders. The smell of the previous show lingers in the canopy, a rider walks into the performance area and starts up one of the motorcycles, it roars into life and makes the boy jump back into the safety of the viewing crowd. Ken's son Alex is merely warming up one of the motorcycles before the show starts. The spieler (the person who addresses the crowd) on the bally (the front of house stage) can be clearly heard announcing the last few places left for the next show.

'Step right up and watch the riders perform tricks and stunts on the vertical wall, a wall as straight up and down as the walls in your very own home! A death-defying spectacle, step right up!' A last couple pay their fee and race to the top of the stairs, eager not to miss the start of the show. The heavy door slams shut with a deafening thud, the spieler is silent, the air is electric with excitement and the history that has been played out in the past seems present within the wall.

The crowd awaits an announcement from below, the riders look up into the gallery with a calm confidence. A moment's silence, then the speakers come to life as Ken's voice addresses the audience.

'LADIES AND GENTLEMEN, WELCOME TO THE WALL OF DEATH'

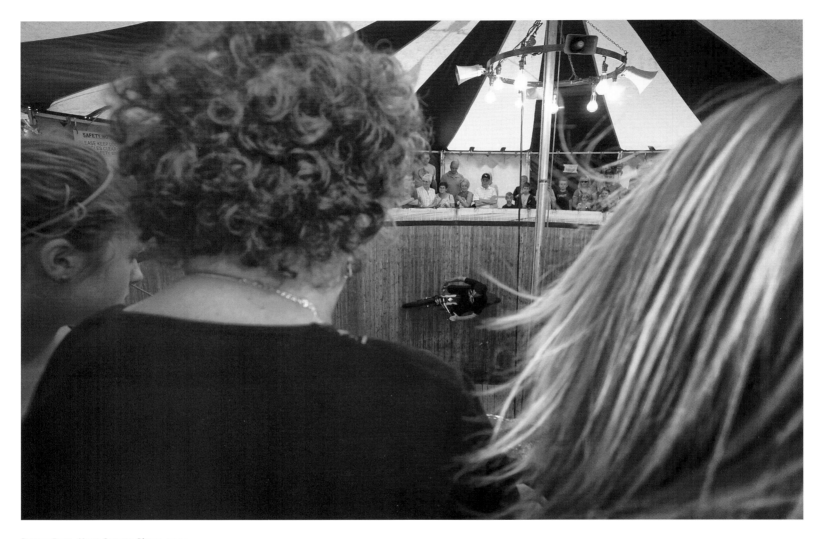

Danny Dare, Kent County Show, 2010.

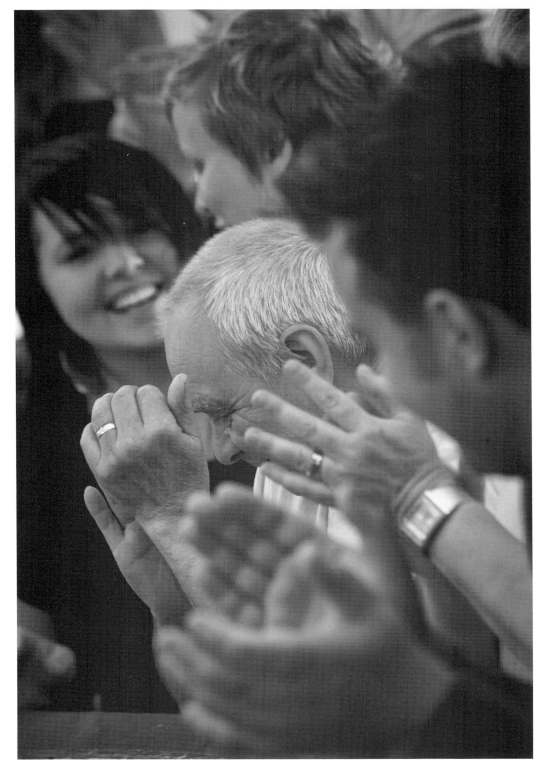

Kent County Show, Maidstone, 2010.

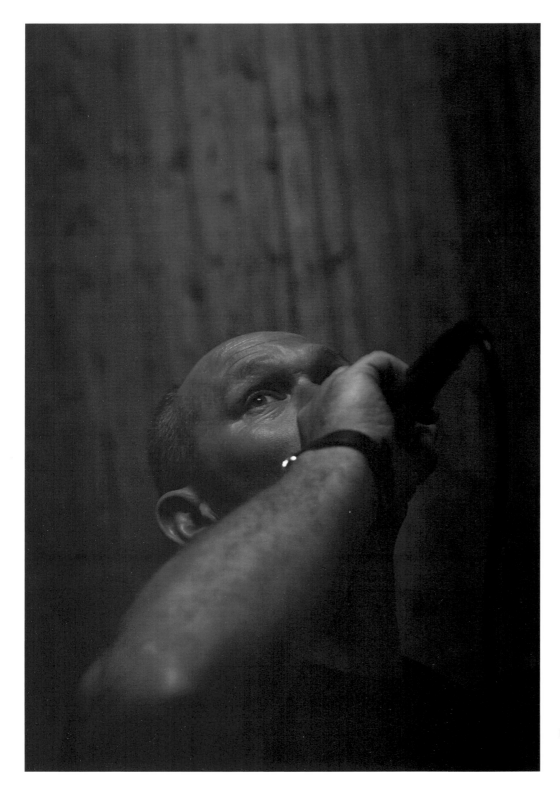

Ken Fox addresses the audience.

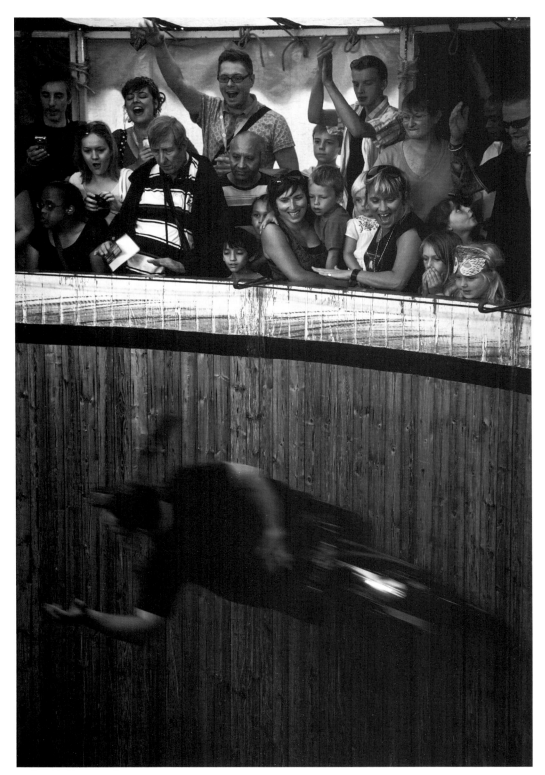

Alex Fox performs to an excited crowd, Croydon, 2010.

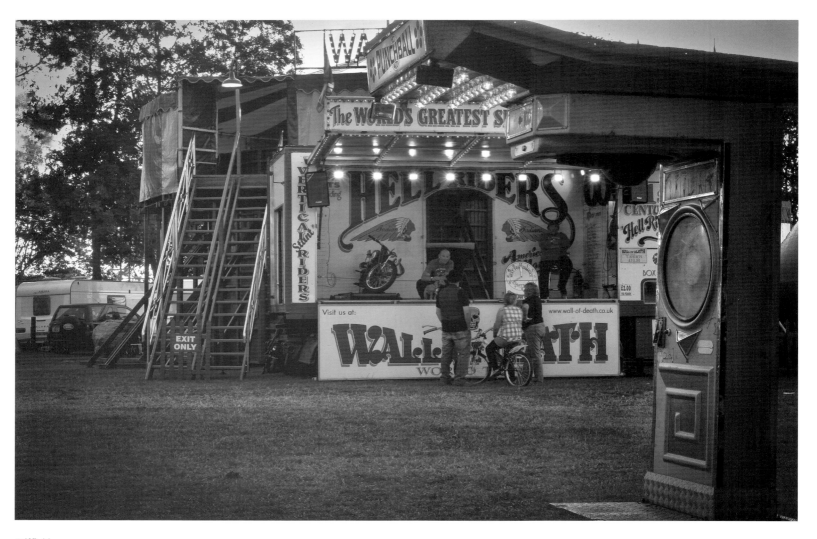

Driffield, 2009.

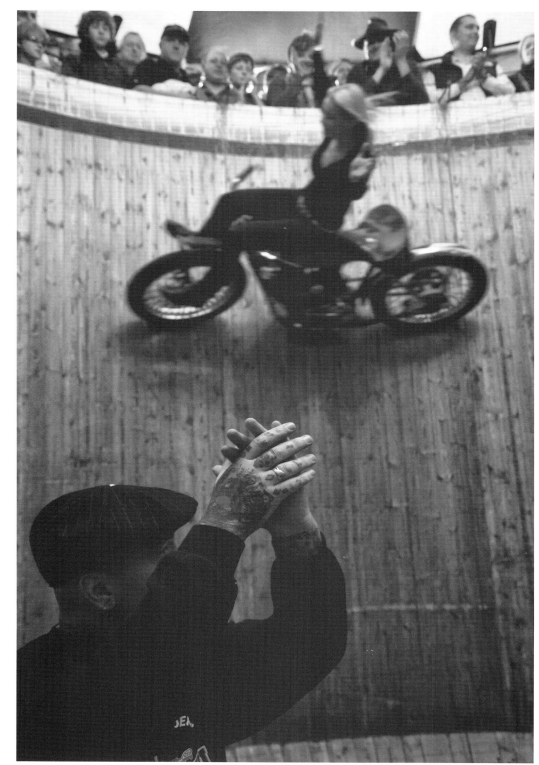

Danny celebrates Kerri's performance, 2010.

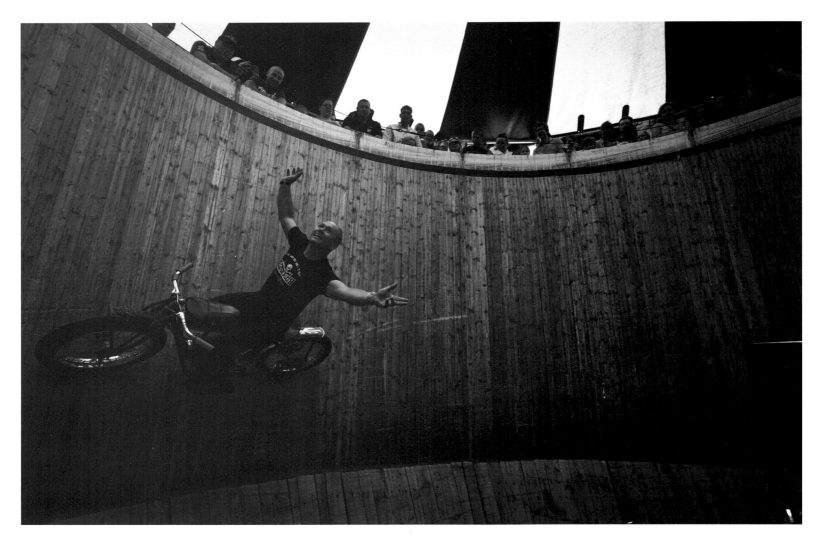

Ken Fox, 2010.

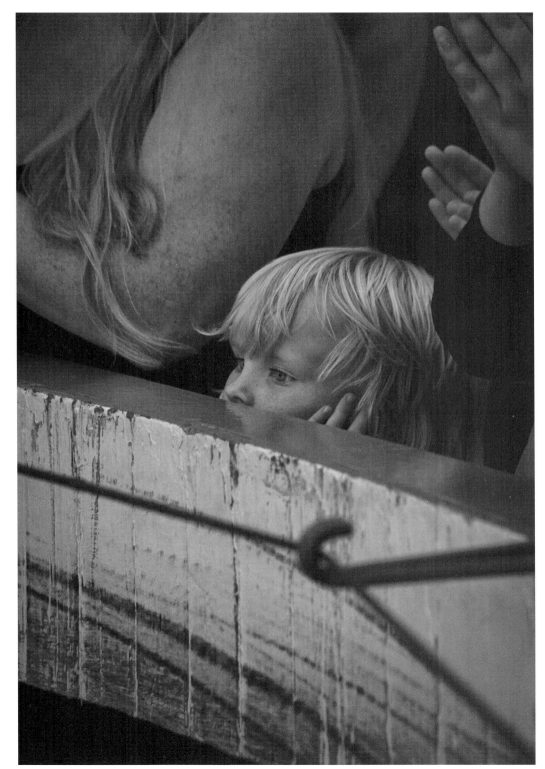

A fascinated young boy waits for a rider to pass, 2010.

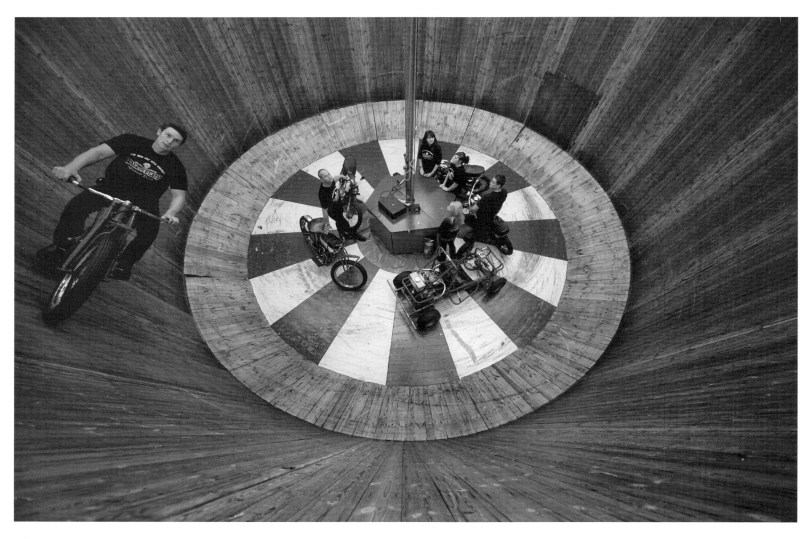

Luke looks for the line, Haddenham Steam Rally, 2010.

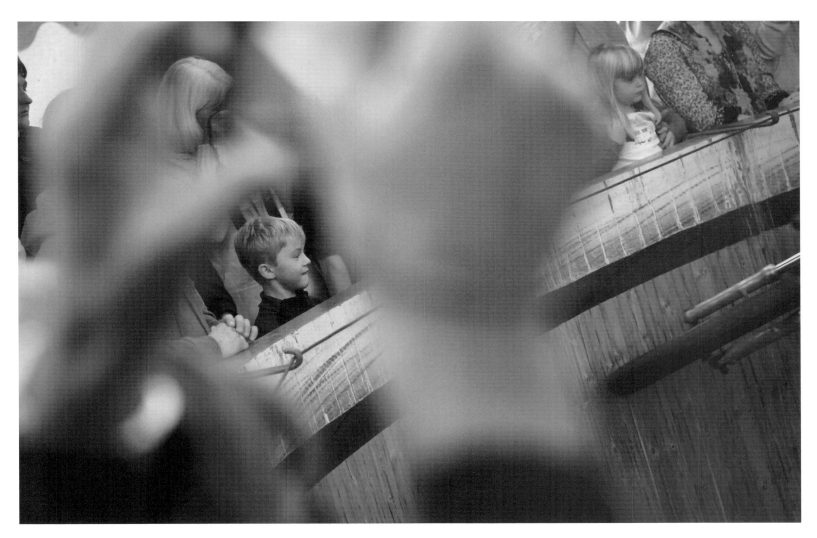

A young fan, Prescott Hill Climb, 2010.

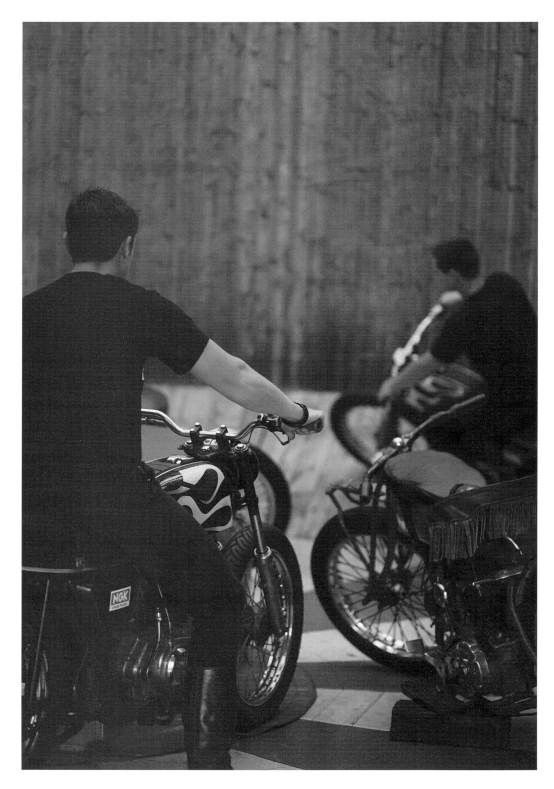

Luke and Alex warm up the motorcycles, Enfield, 2010.

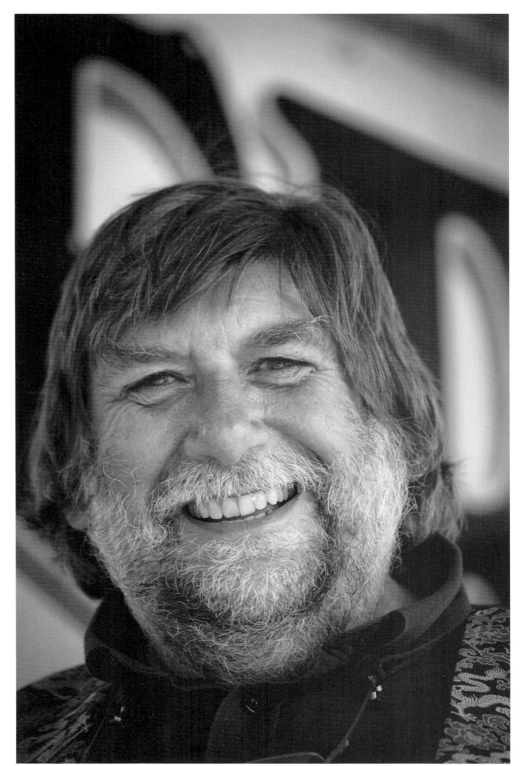

The spieler Neil Calladine, 2010.

Entrance to the wall, Driffield, 2009.

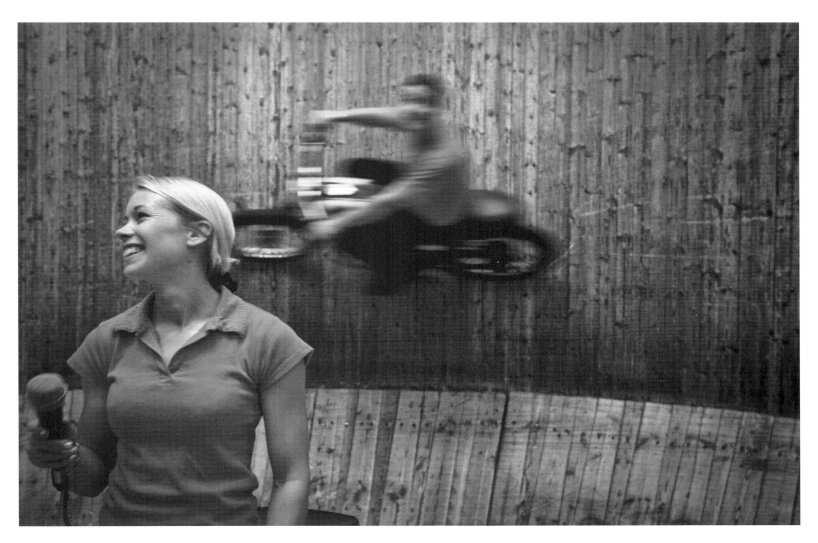

Kerri and Luke, 2009.

Ken Wolfe, Ipswich, 2010.

Lincoln, 2009.

Evening shadows, 2010.

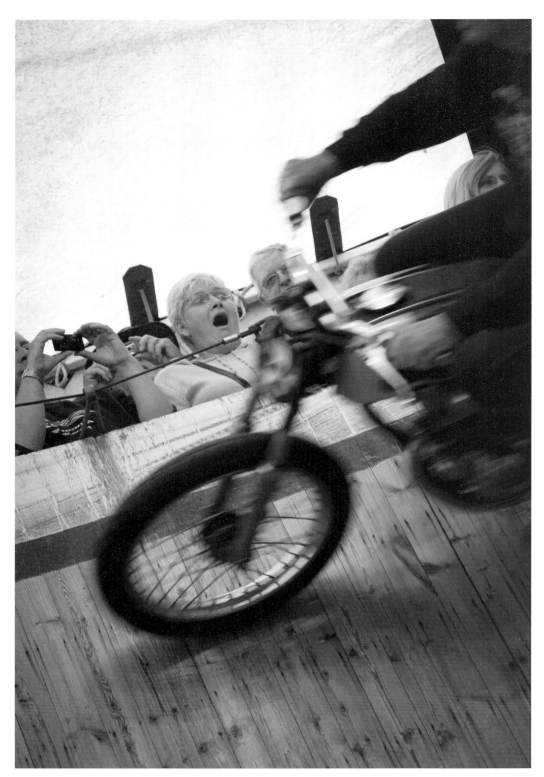

Danny shocks the crowd, 2010.

DANNY IS ASTRIDE HIS HONDA waiting for the ok as Ken finishes his spiel and walks towards the centre of the wall. He glances at Danny and, with a wink, Danny starts his motorcycle. His heavily tattooed hand twists the throttle and the Honda is alive. Placing the microphone on the centre table Ken smiles at Danny as he makes his way around the banking track, the eighteen panels chattering loudly as Danny increases his speed. The noise intensifies as he reaches the correct speed to be able to ascend the vertical wall. You can hardly focus, as he rides around the bottom half of the wall. In a blink of the eye, and producing a loud gasp from the audience, he is riding just inches away from the safety cable! You can feel the vibrations under your feet as you are rocked backwards and forwards by the moving wall.

Although there are never many, this is the point where the unsure or nervous vacate the show. They are led carefully to the exit by one of the support crew. If you are viewing the spectacle of the Ken Fox troupe for the very first time, the speed which Danny rides around the wall in the opening performance can seem unbelievable, shocking and almost insane. After a display of straight wall riding, Danny starts to descend as his speed reduces. With one hand raised in appreciation of the applause coming from the energised crowd, his act comes to an end. Danny swings his leg over the saddle and stands next to the machine that has carried him around the wall. The rest of the riders who are present clap in a respectful manner. Before you can regain a normal composure, Ken starts the go-kart.

'Ladies and gentlemen – Ken Fox!' Kerri announces. By the time Kerri replaces the microphone, Ken is already flying around the wooden cylinder aboard the go-kart. The audience moves backwards in sequence around the top of the wall as Ken approaches, like a rippling effect in a pond when a stone has been thrown in. Mobile phones switched to camera mode try to track Ken as he thunders up and down the pine panels like a circular roller coaster.

The order of the show can change throughout the day keeping things fresh and exciting but on this occasion Alex and Jaimi are up next. This is to be a double act that features Alex riding with Jaimi as the pillion passenger. Unbeknown to the visiting crowd, Jaimi does not always take a back seat. When the showgoers are having breakfast at home, Ken and his team are already up maintaining some of the bikes and equipment. When this is done it's time for a practice session. And the next potential wall rider to learn the ropes is Jaimi. In May 2010 Jaimi started her training with Ken to become a Wall of Death rider. Building Jaimi's confidence slowly is the only way to unlock her courage. With Ken's teaching skills it will not take long before the banking track will be mastered. As long as Jaimi can progress safely, the next stage will be the huge mental step of leaving the safety of the floor and banking track to the unnatural world of riding a motorcycle around a vertical wall of wood.

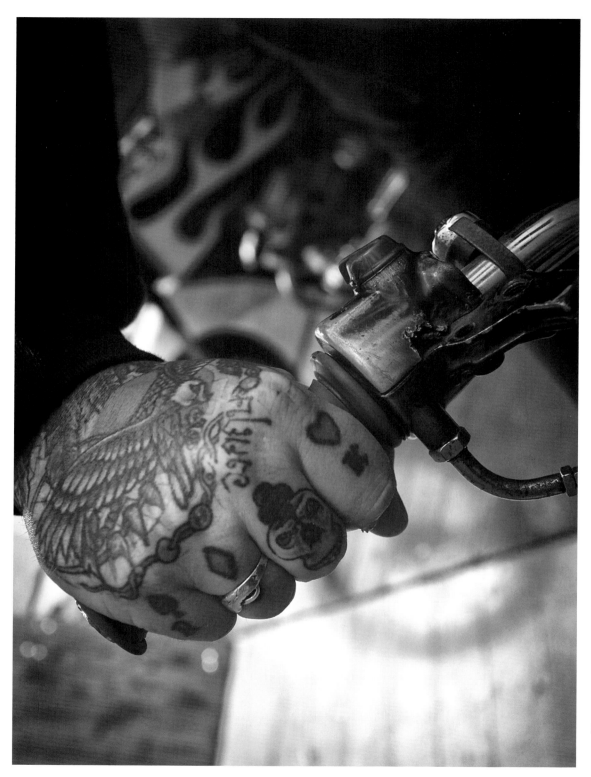

Danny on the throttle, Dorking, 2010.

The banking track which leads to the vertical wall.

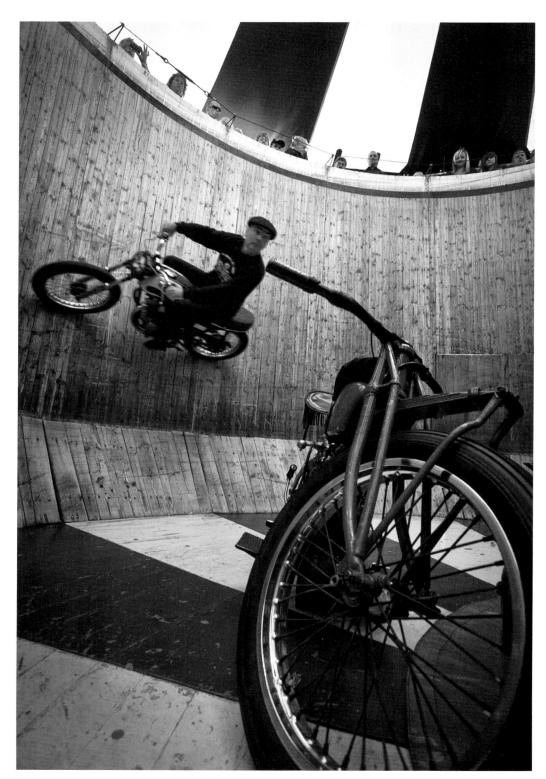

Danny, 2010.

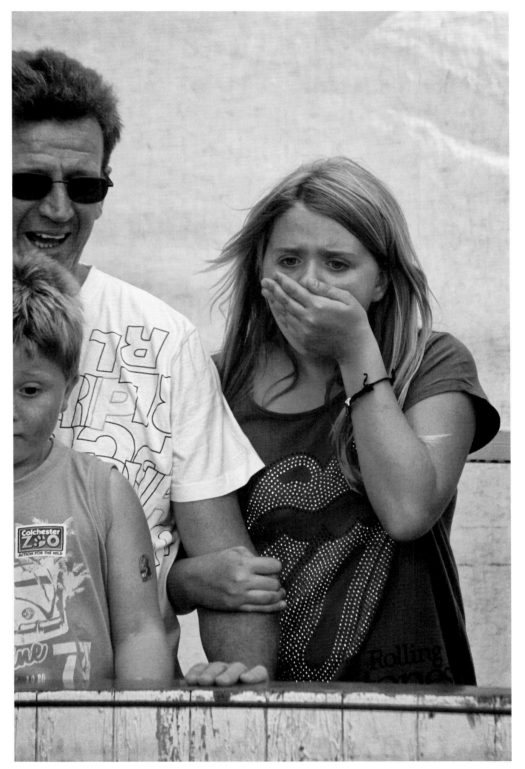

'Disbelief', 2010.

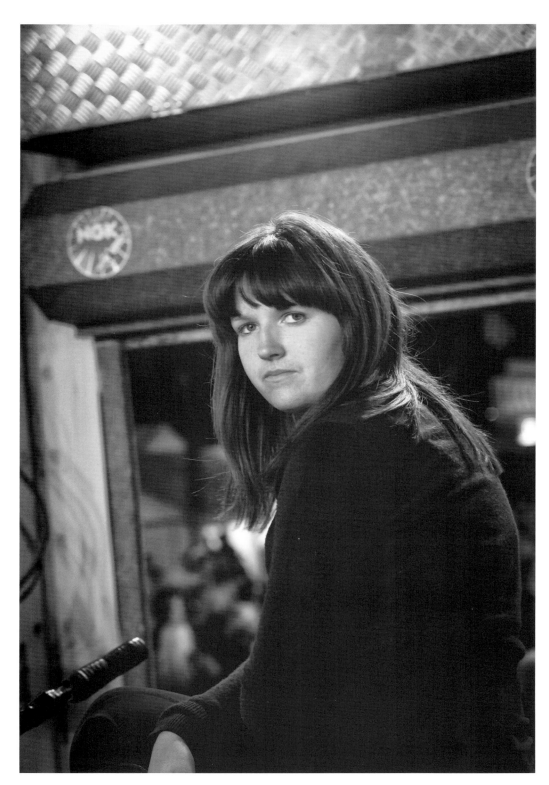

Jaimi, Dorset, 2010.

Royal Cornwall Show, 2010.

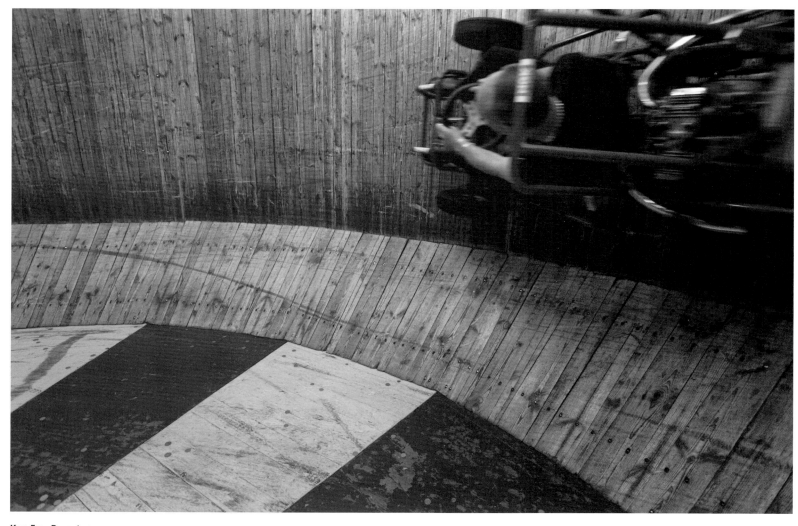

Ken Fox, Dorset, 2010.

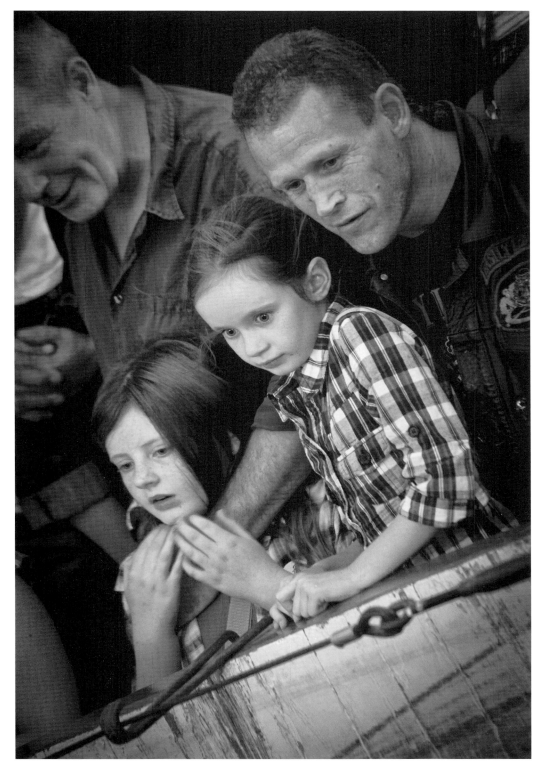

Amazement, Croydon, 2010.

Royal Cornwall Show, 2010.

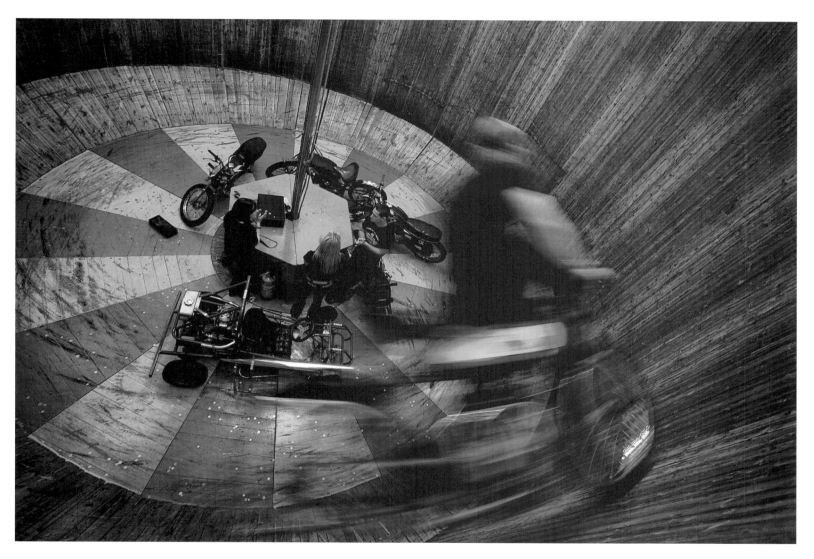

Ken Fox flying around the wooden cylinder, 2010.

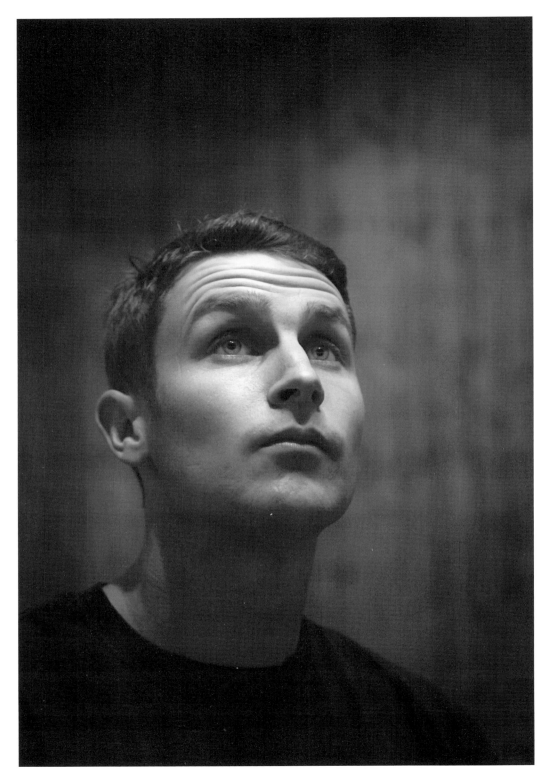

Luke Fox, 2010

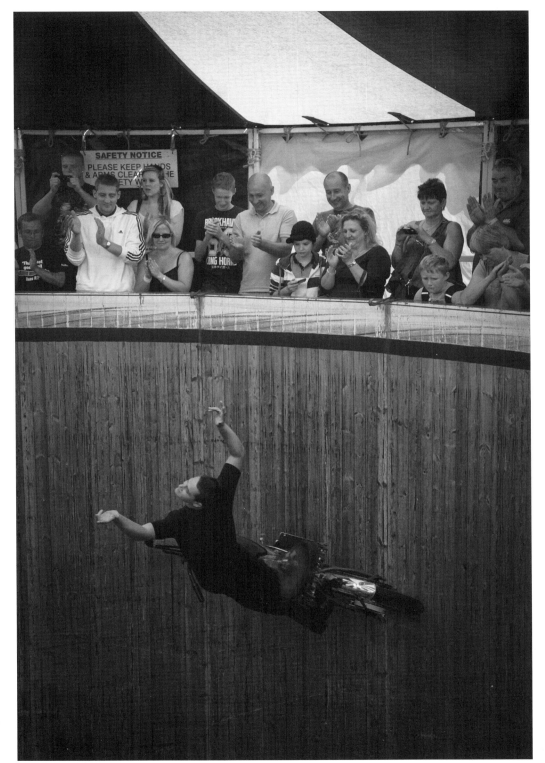

Alex Fox, 2010.

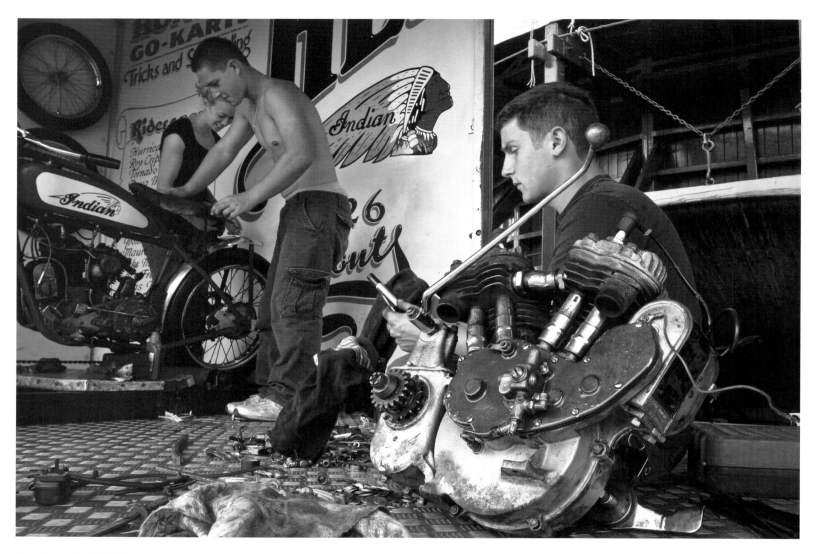

Morning repairs, Driffield, 2009.

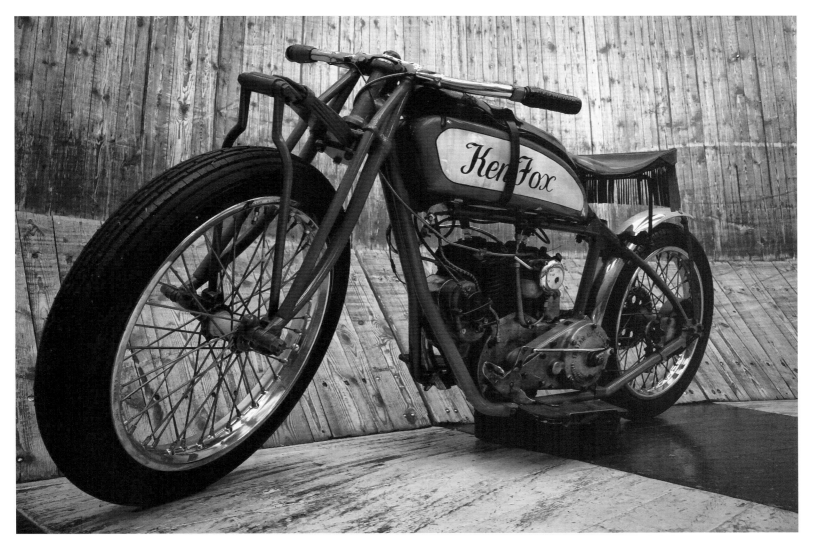

The Indian motorcycle of Ken Fox, 2010.

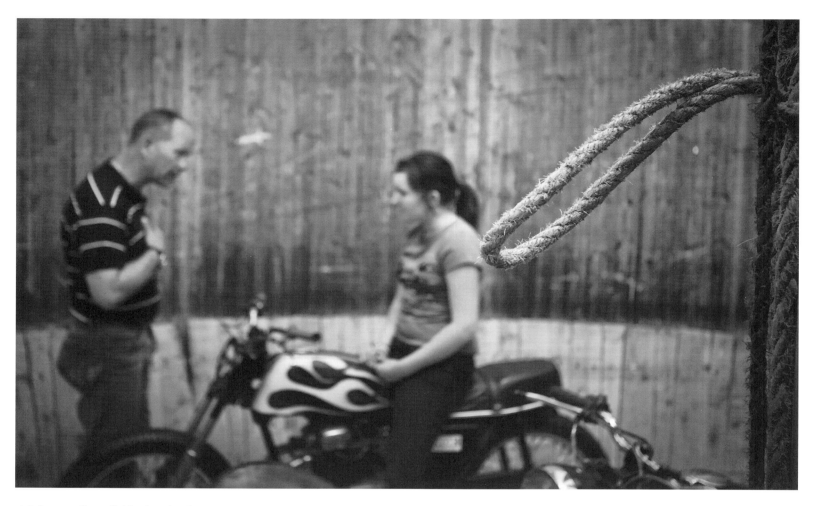

Jaimi, apprentice wall rider, learning the ropes, 2010.

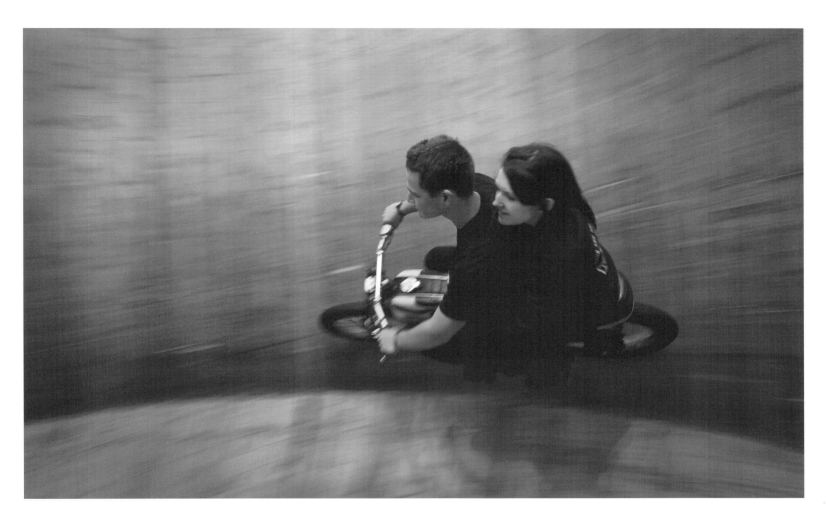

Jaimi rides pillion with Alex Fox, Dorking, 2010.

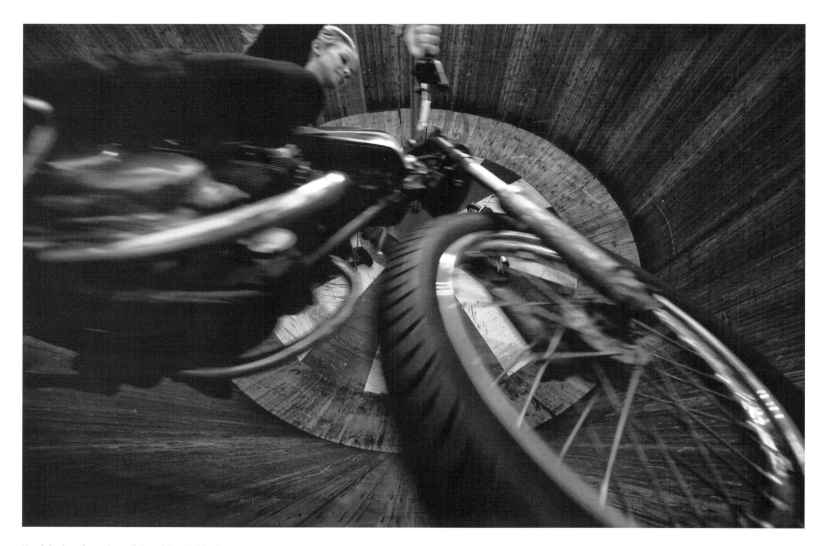

Kerri, inches from the safety cable, Haddenham, 2010.

KERRI WALKS CALMLY up to the ageing Indian Scout that stands before her, her smile reflected in the bright red paintwork of the petrol tank. With her arms stretched out across the wide chrome handlebars she lifts herself onto the motorcycle and her feet come to rest on the side footplates of the Indian. She raises her right foot and places it firmly on the kick-start. With a firm kick the 600cc engine bursts into life. The kick-start pedal is removed and passed to Ken, the clutch is pressed and the hand shifter is pulled into second. The left-hand throttle is twisted towards her and she slowly moves off. Kerri is now on the banking track, her blonde hair flowing behind her, wooden panels approaching in front. The skull-and-crossbones belt buckle she wears sparkles from the eight lightbulbs which illuminate the show. Kerri glides smoothly onto the wall, keeping an eye on the line and, as her speed increases, she steadies herself as she starts her trick ride.

Kerri moves around the 1928 Indian like a ballet dancer uses the balance bar – graceful, yet all the time focussing on the performance. After several tricks the crowd are now in a state of amazement as Kerri finishes off her act with a display of wall riding that will make the hairs on the back of your neck stand on end. Kerri swings her left leg over the bike; she is now riding side-saddle. When a constant speed is achieved, Kerri releases her grip from the handlebars and the applause from the crowd is deafening as she rides side-saddle facing the crowd, with her toes just inches away from the passing wall. The constant applause brings inquisitive customers to the box office as Kerri descends to the safety of the floor.

All riders have different styles and their bikes are carefully adjusted to suit their needs. Ken alters the rake and forks of each Indian motorcycle to the requirements of each rider. Like a tailor uses his chalk for his measurements, Ken uses his calculations and thirty-year experience to find the correct fit. Each bike will behave differently when the work has been completed. Alex and Luke both retain some characteristics of their father's style, Luke's being fast and precise, strong and calculated, using every part of the wall during his dips and dives routine. The gold ring bearing his surname flashes as he waves to the cheering crowd. Luke's Indian bobs and weaves through each trick ride, flying over the scars that are embedded in the wall from previous fallen riders.

From the age of eleven, Luke's skills have been perfected making him the stylish rider he is today. Alex also started riding aged eleven, and has gone on to be one of the youngest trick riders of modern times. At fourteen Alex could ride around the wall on his 1920s Indian standing on the 4in-wide footplate with his arms raised in the air – a calm, yet confident style. Luke and Alex are the fourth generation of the Fox family to be associated with the Wall of Death – their pride is constantly present with each performance making them showmen in their own right. There is healthy competition present between Luke and Alex, as there would be between brothers in any family. But in their environment there's a lot more at stake.

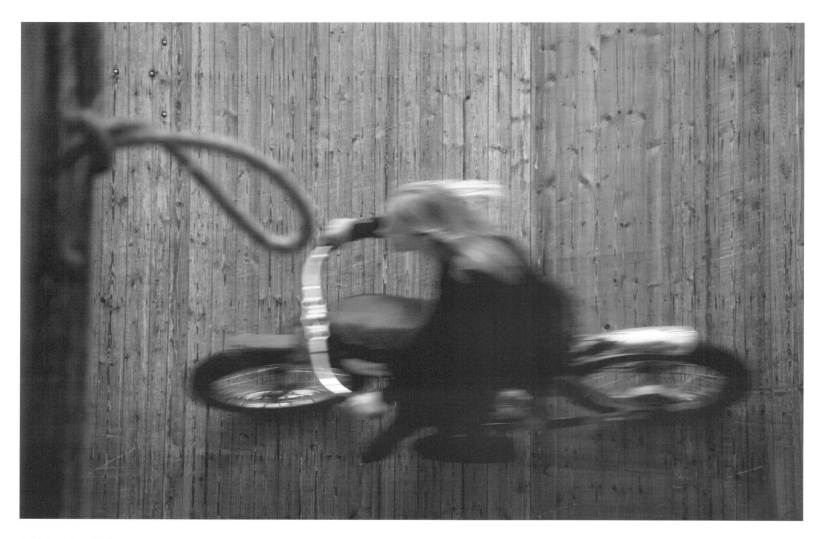

Kerri, Kent County Show, 2011.

Kerri riding on the handlebars, Stafford, 2009.

Witnessing the wall for the first time makes the hairs on the back of your neck stand on end, Bedford, 2010.

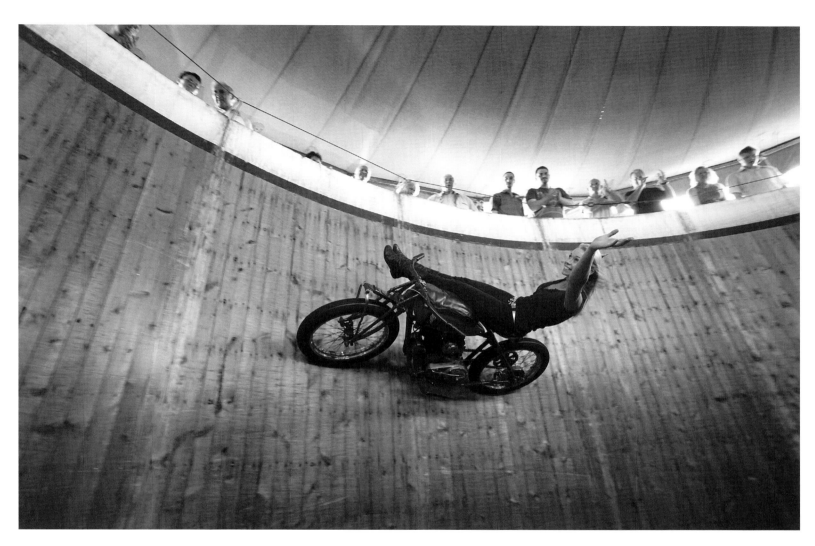

Kerri trick-riding on her 1920s Indian, 2010.

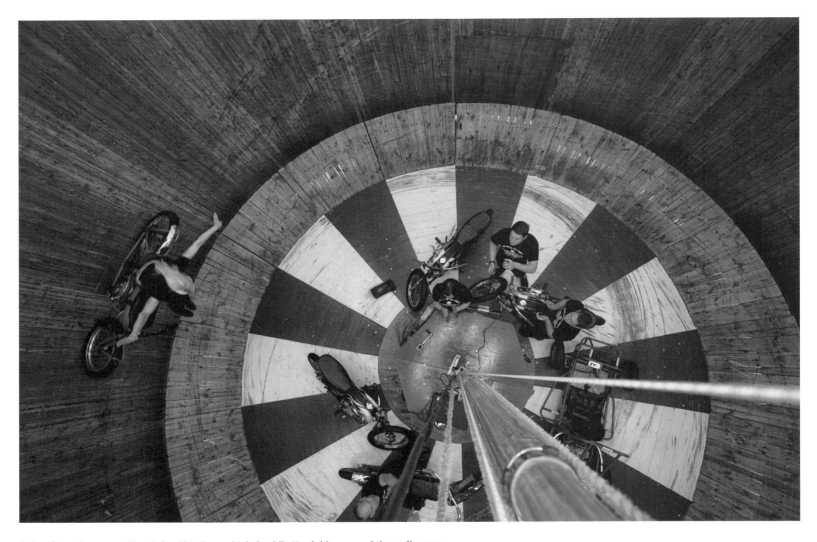

A view from above sees Ken, Luke, Alex Fox and Jaimi, while Kerri rides around the wall, 2010.

Lincoln, 2009.

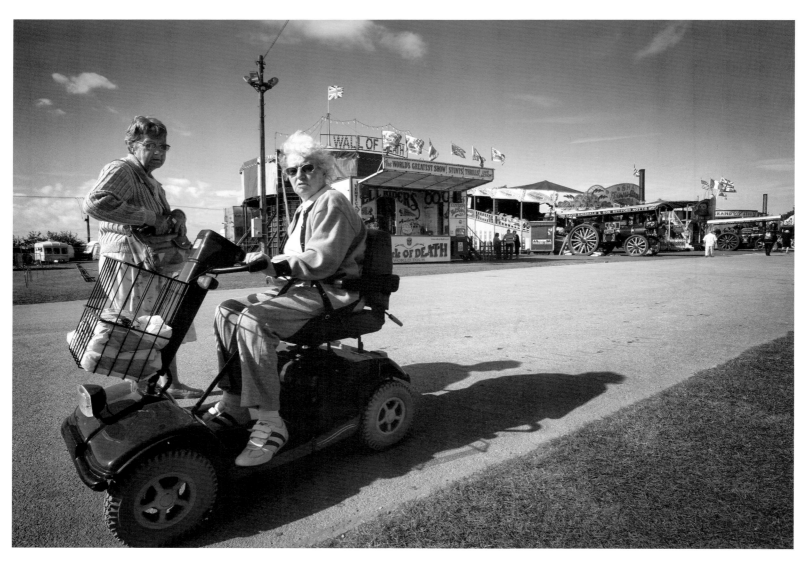

Lincoln, 2009.

Kerri, 2011.

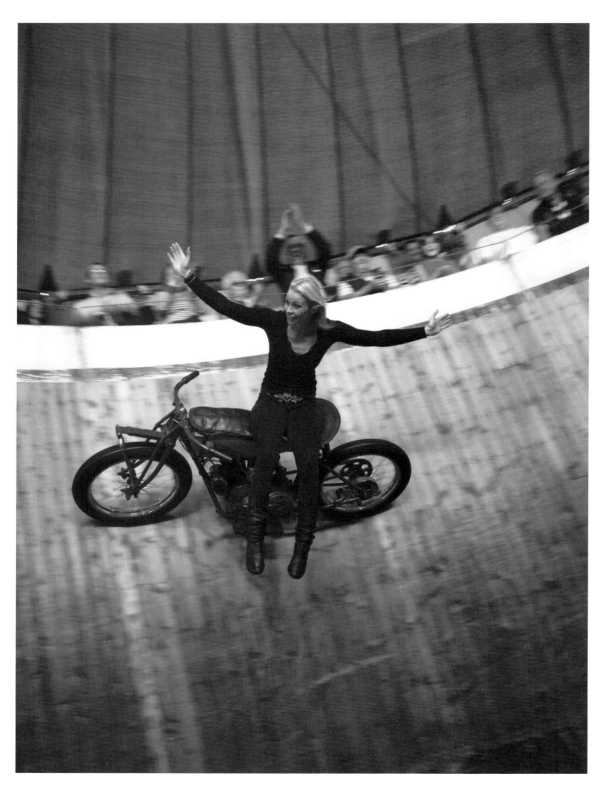

Kerri, Henham Rally, Suffolk, 2010.

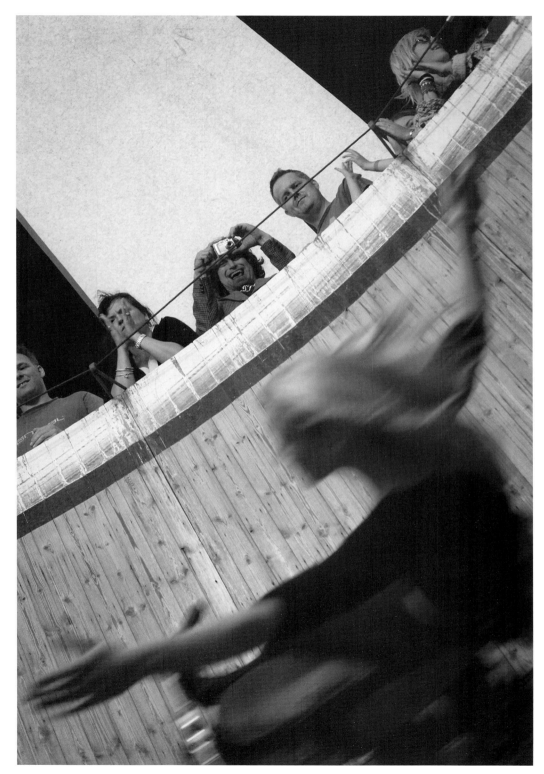

Kerri, Dorset, 2010.

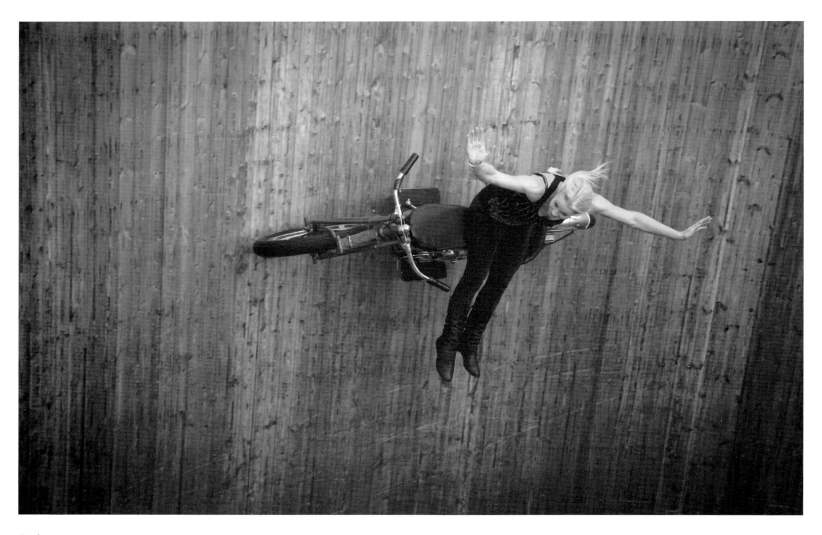

Kerri, 2010.

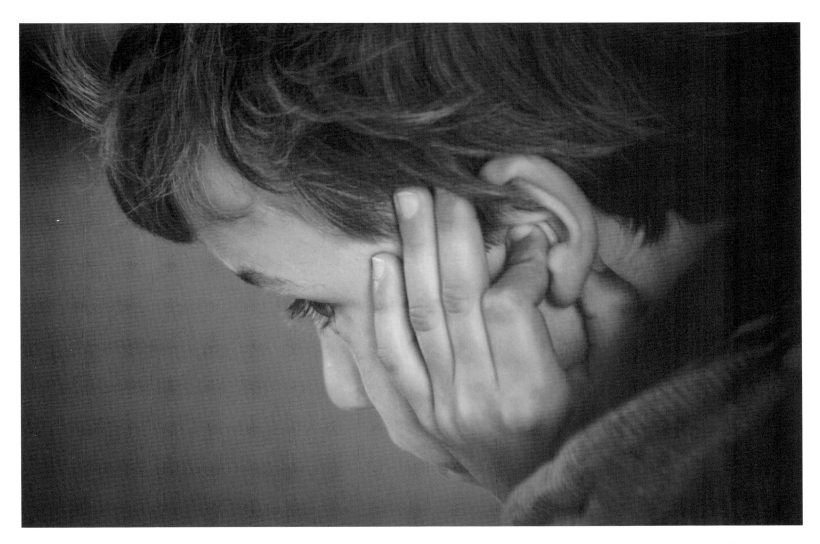

The motorcycles are started, Pickering, Yorkshire, 2010.

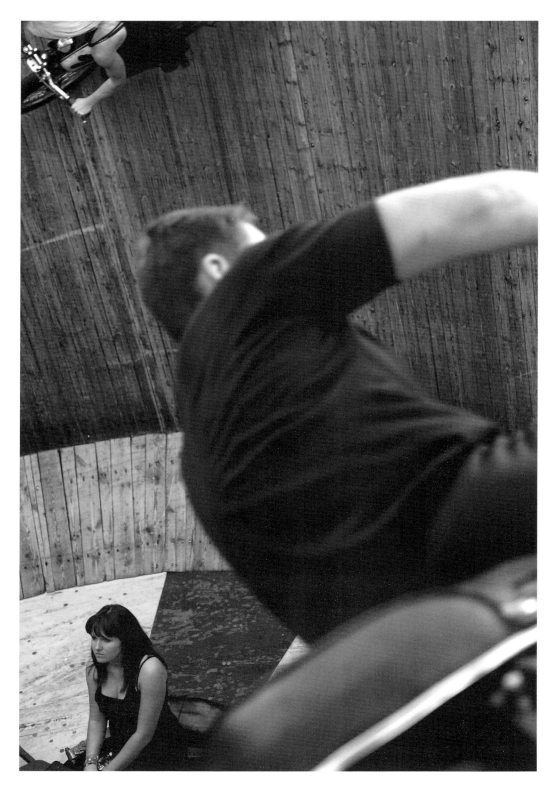

Jaimi, Alex and Kerri, 2010.

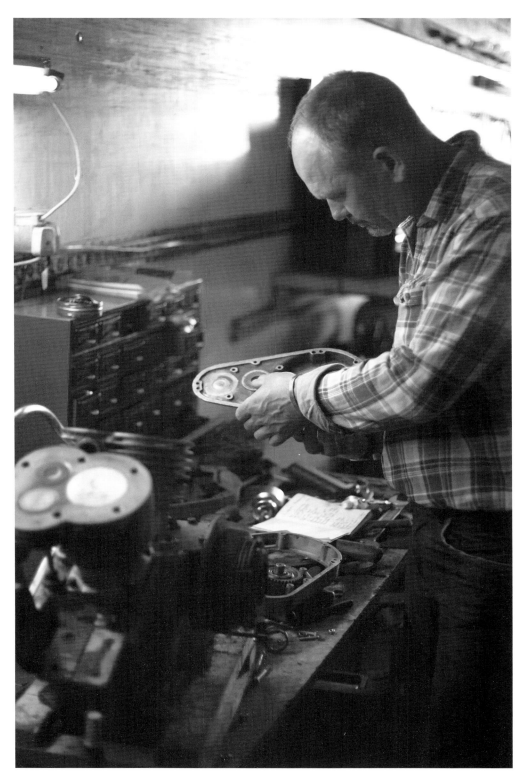

Ken Fox during an engine rebuild at
their winter quarters, 2011.

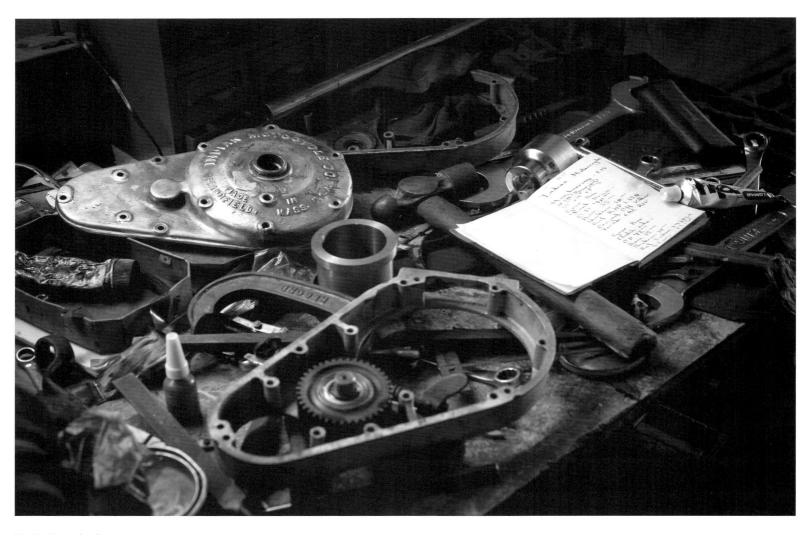

Ken Fox's notebook, 2010.

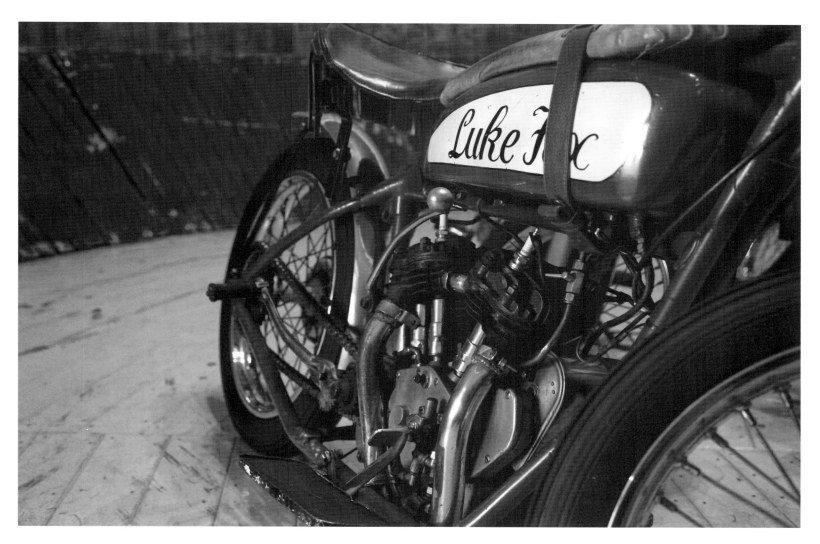

The Indian of Luke Fox.

Cowpie Country Show, 2011.

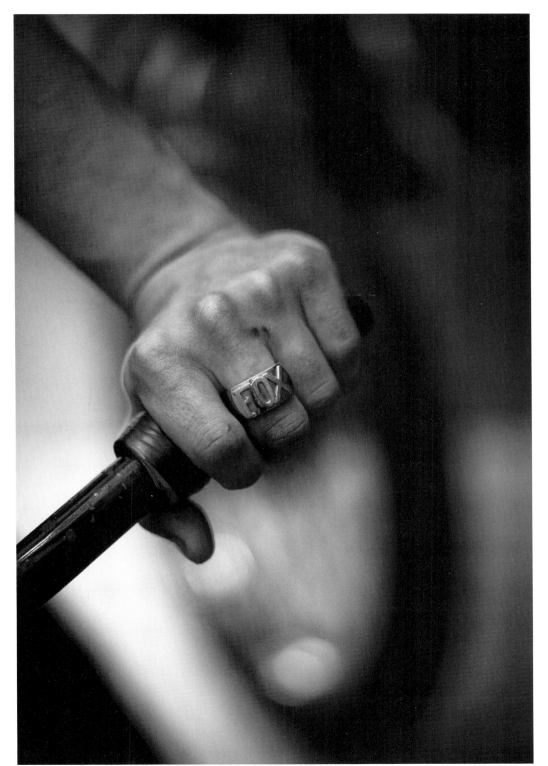

Luke Fox, Enfield, 2010.

Luke Fox – the next generation – 2010.

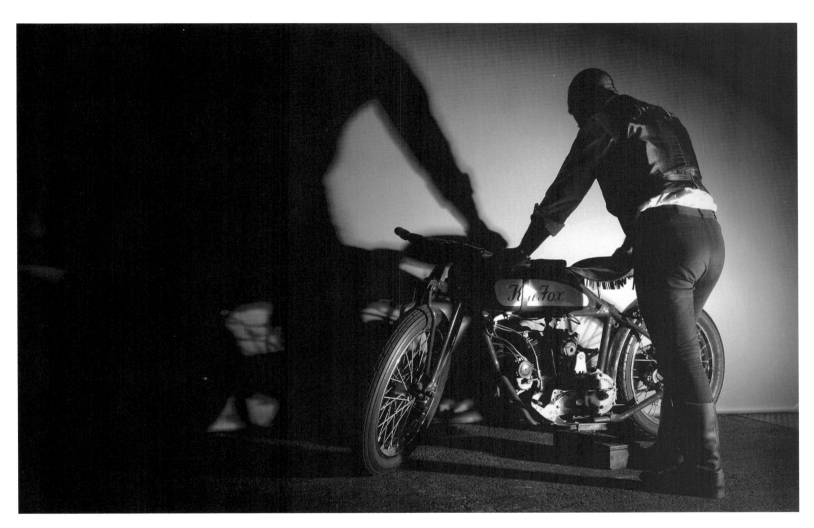

Ken Fox at the National Theatre of Scotland, 2010.

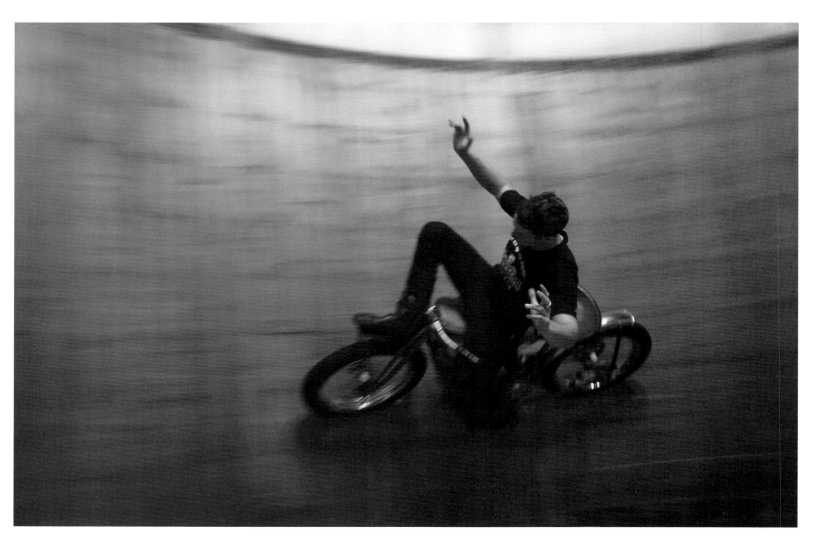

Luke Fox, 2010.

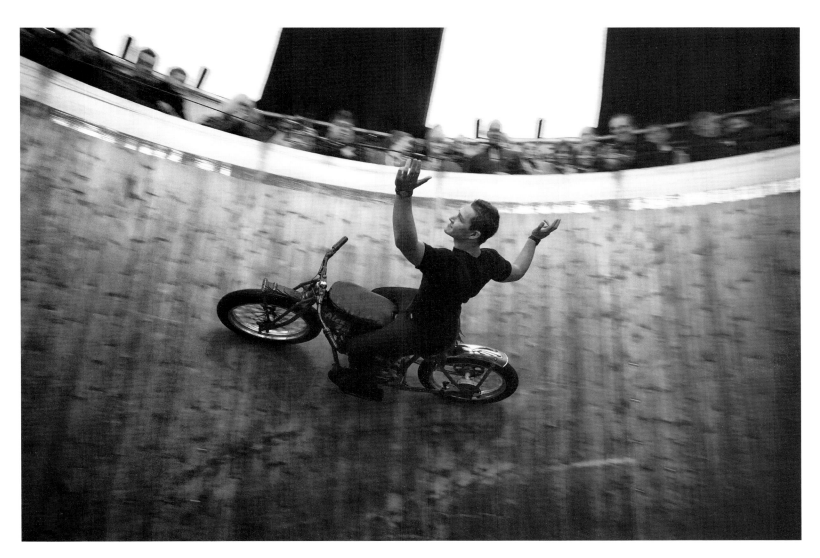

Alex Fox, 2010.

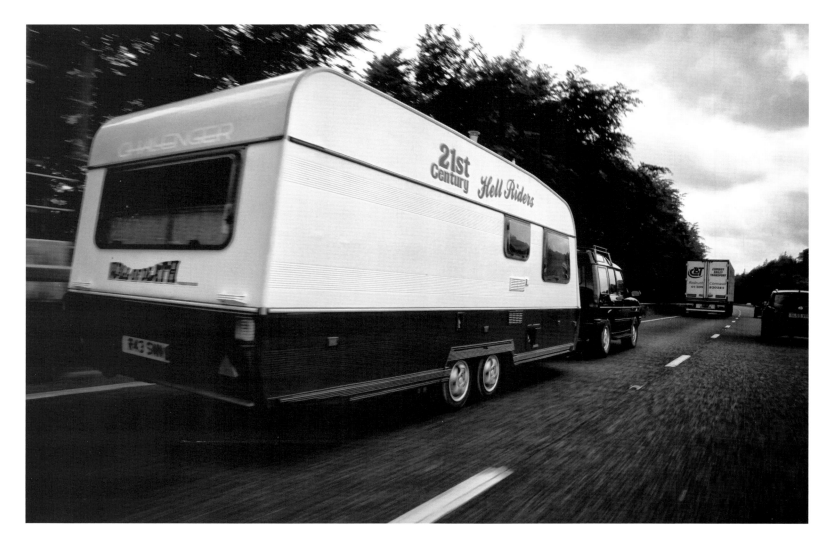

On the road again, 2010.

THE SHOW'S ON THE ROAD AGAIN, having packed up earlier while the adrenaline was
still high and the weather good. It's a performance in itself when you consider the complete wall with all the equipment – the
bikes, lighting, stairs, panels and uprights – all packed in the back of the lorry and a trailer in less than two hours. This is
achieved thanks to the dedication of Ken and his wife, Julie, and their family and friends who help pull down the wall at the
end of every show, and to the way every member of the team keeps their sense of humour while packing up in this demanding
environment.

Ken planned and constructed the wall back in 1995 and every part has its place within the lorries and trailers that transport
this wonderful spectacle around the country. The Ken Fox troupe travel great distances fulfilling their busy schedule, from
England to Scotland, Ireland and also Europe, but on this occasion the convoy makes its way down the narrow winding roads
of the Devon countryside. The painted Wall of Death skull rider on the side of the bright red lorry floats above the hedgerows,
as the Dingles Fairground Heritage Centre approaches. As the dust settles, the vehicles come to a standstill. The majority of the
convoy has parked in the communal area that has been set aside for the living quarters. The Scania lorry, along with the bally
trailer is positioned, ready to be unloaded.

After breakfast it will be time to build up the wall. Under the watchful eye of his mother, Alex will have the important task of
building a level base. This will be Alex's first solo attempt as team leader, and all the crew are present to help unload and piece
together this giant wooden jigsaw. The floor has to be level which means every last one of the eighteen sleepers that support
the floor has to be spot on. Several hours have passed and the sleepers are laid out like a massive spider's web. Alex crouches
down carefully checking his work. Going round the complete circumference, sleeper by sleeper, seeing if the bubble of his spirit
level rests confidently in the middle. After several minutes and with a big grin on his face he rises triumphant. Julie watches the
humorous banter grow as each member of the team claims their individual involvement as being key. It's a good start. The rest
of the wall including the heavy panels will be constructed tomorrow – now it's time for a well-earned cup of tea. Talk turns to
the plans for the next couple of days – the mundane tasks of washing, shopping and repairs that all need to be done before
Saturday – but for now relaxing around the surroundings of the great museum is the order of the day.

The following morning everyone is gathered around the table giving a communal feel to the banter. Although the floor of the
wall was completed the day before, there is still a lot of hard work to be done today. The heavy panels are raised one by one.
The early summer breeze covers the panels with dust making them hard to handle and this will also make riding conditions
within the wall very hazardous for Ken and his team once the show begins.

Everyone's pace seems to increase as the afternoon slips into early evening. The stairs are in place along with the gallery area
and the tilt (overhead canopy) is being pulled in to place. The wooden packing pieces that support the sleepers are checked
for tightness while the Indian motorcycles are lined up neatly on the bally waiting to perform. The famous Wall of Death sign
sparkles in the inky blue sky as the lights are tested for the first time. At last! The build-up is complete.

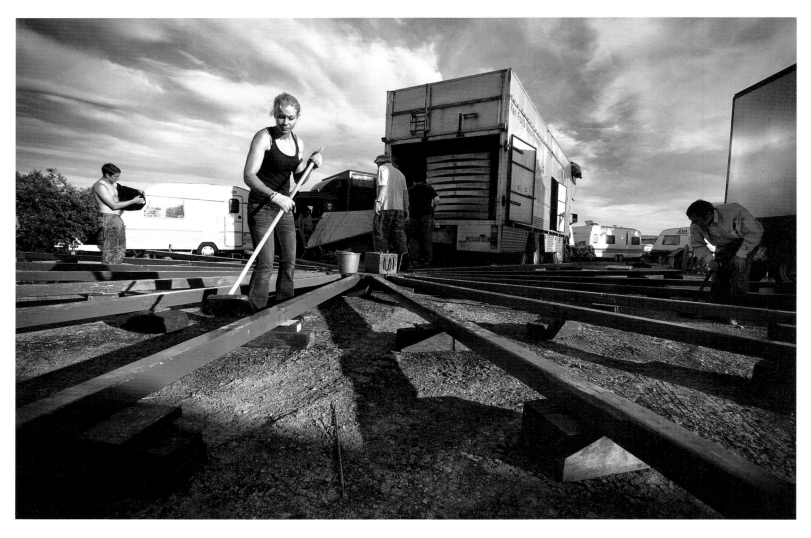

Cleaning the wooden sleepers, Cornwall, 2010.

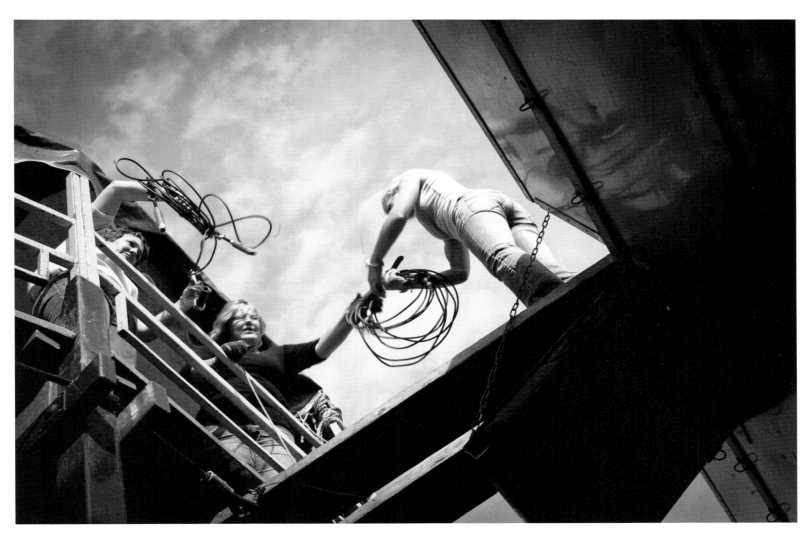

Corrinne, Julie and Kerri, 2009.

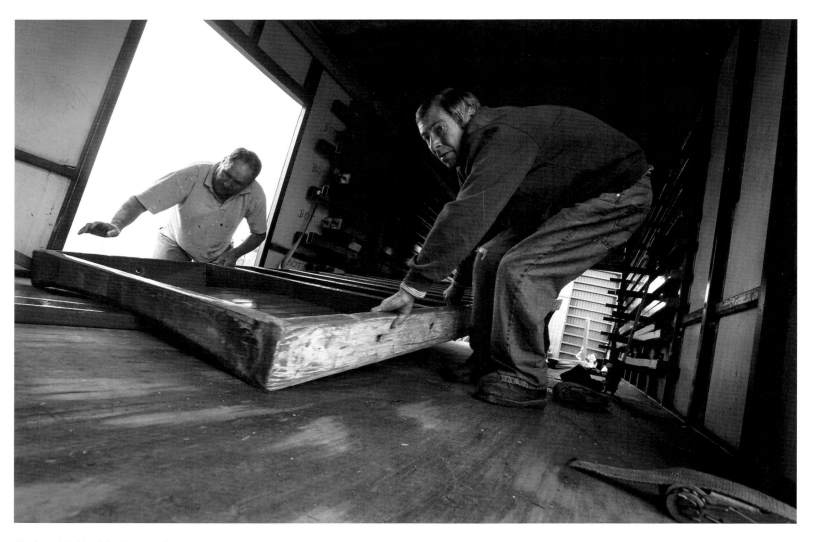

Martin and Jed load the first panel, 2010.

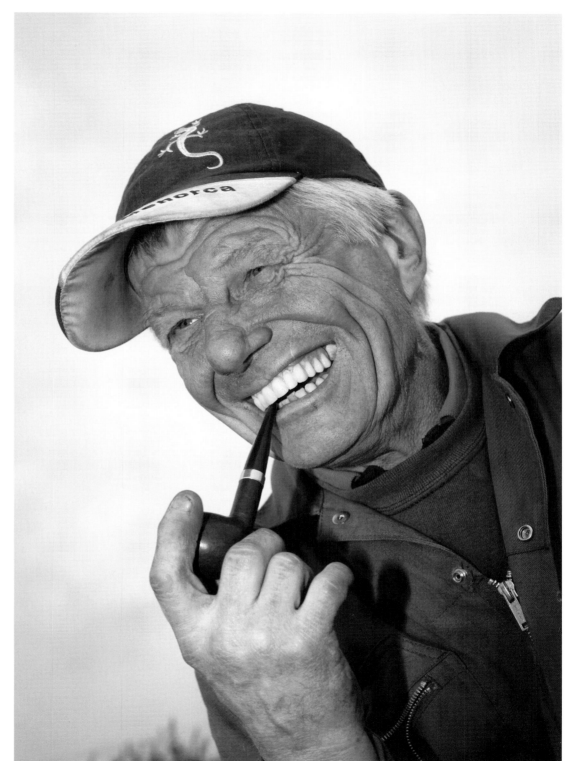

Phil, 2009.

Approaching the Dingles Fairground Heritage Centre, 2010.

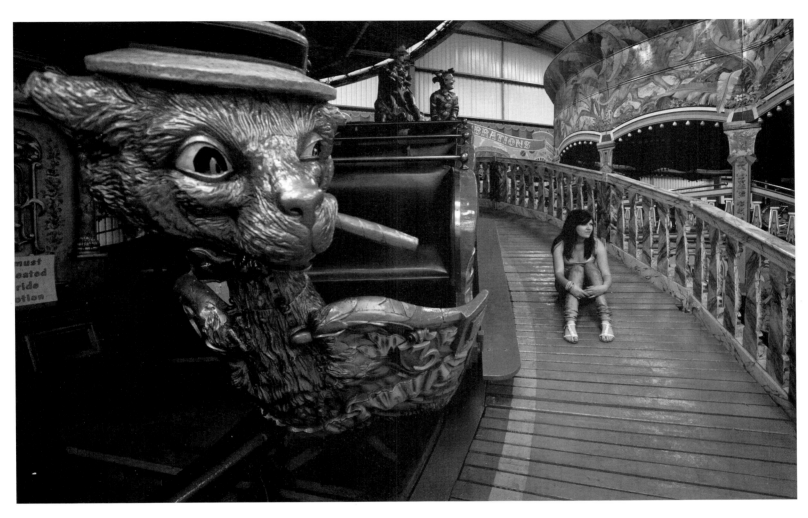

Jaimi on the eve of her first public performance, 2010.

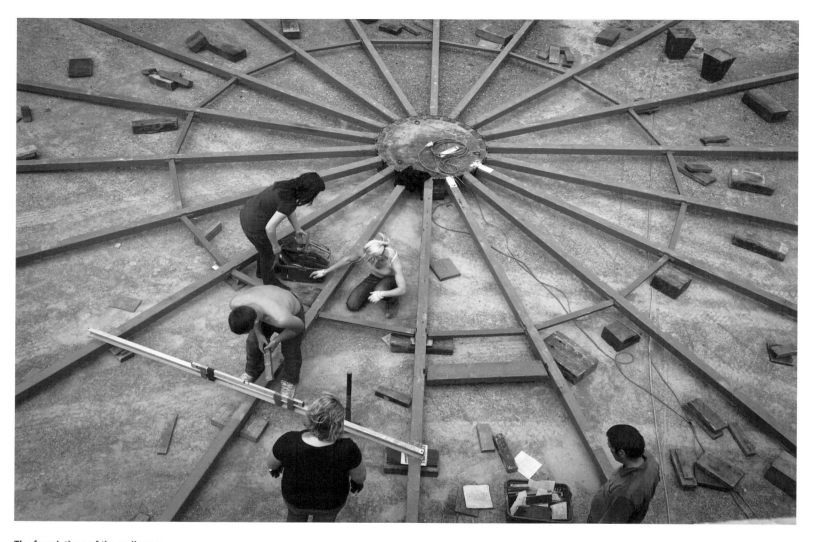

The foundations of the wall, 2010.

Julie with the Foden lorry she regularly drives, 2011.

Alex Fox, 2010.

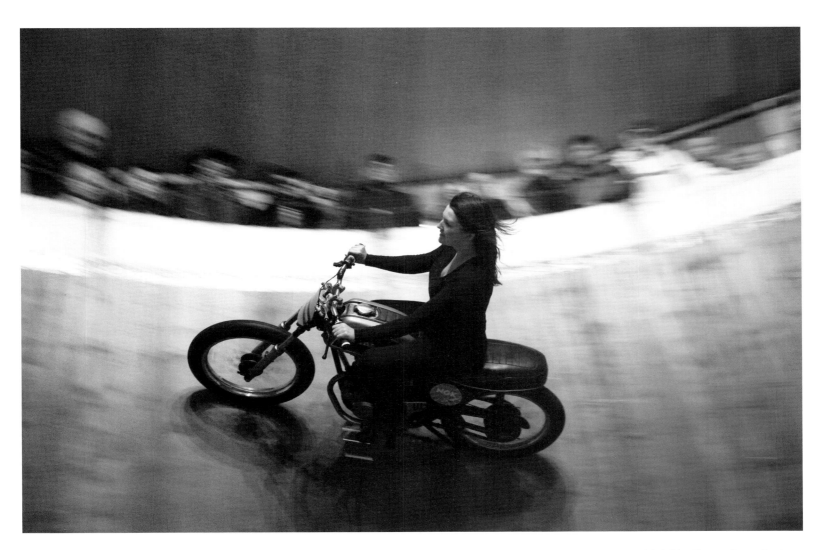

Jaimi rides the wooden walls, 2010.

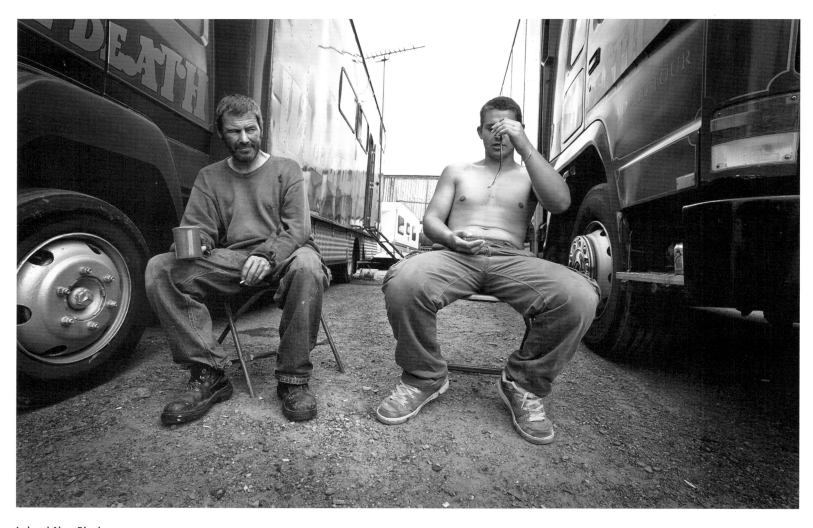

Jed and Alex, Dingles, 2010.

Willie, Dingles, 2010.

Kerri in the hall of mirrors, Dingles, 2010.

Fireman Steve, 2010.

Building up, 2010.

Ken Wolfe, Dingles, 2010.

Jaimi, 2010.

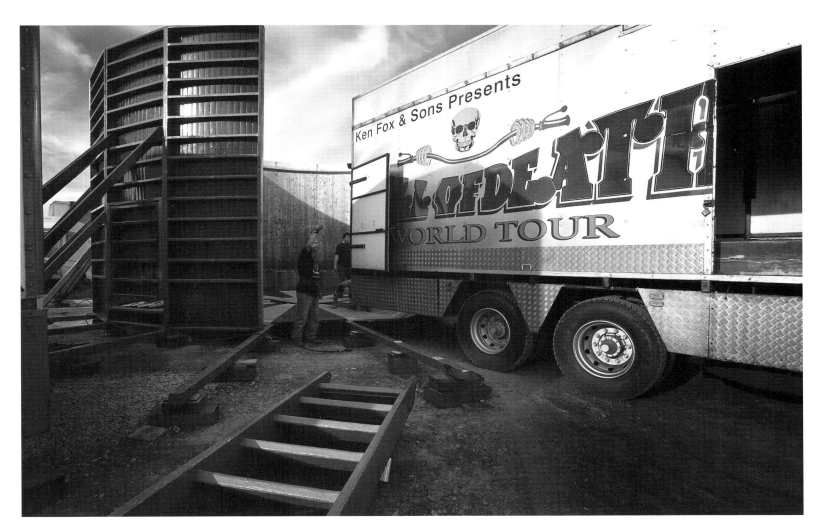

Royal Cornwall Show, 2010.

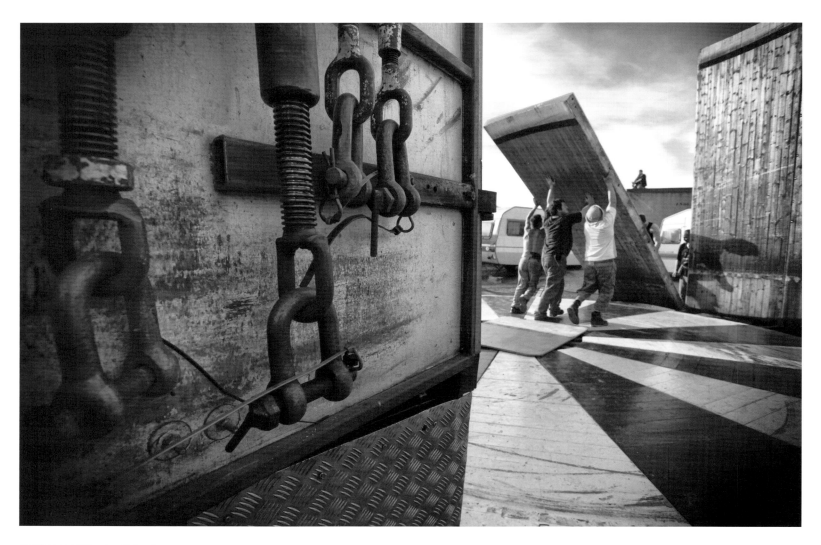

Another panel is raised into place, 2010.

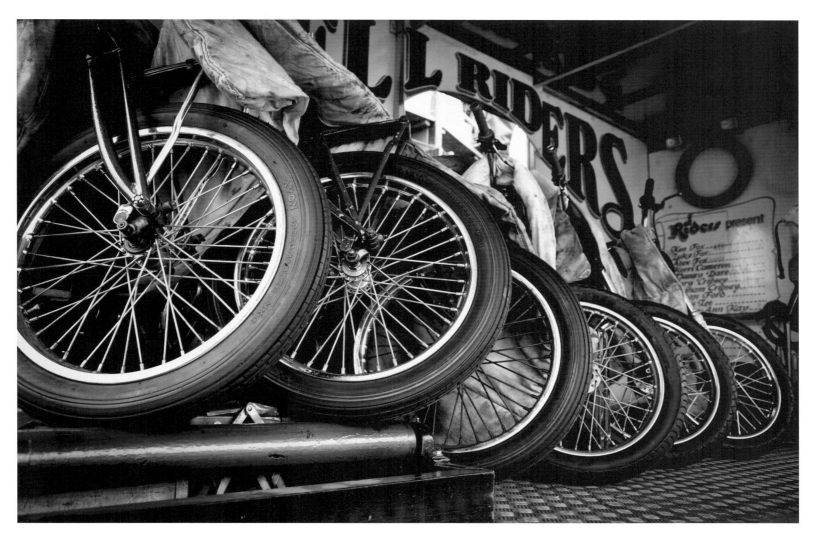

Motorcycles waiting to perform, 2010.

The Wall of Death sign sparkles in the evening light, 2010.

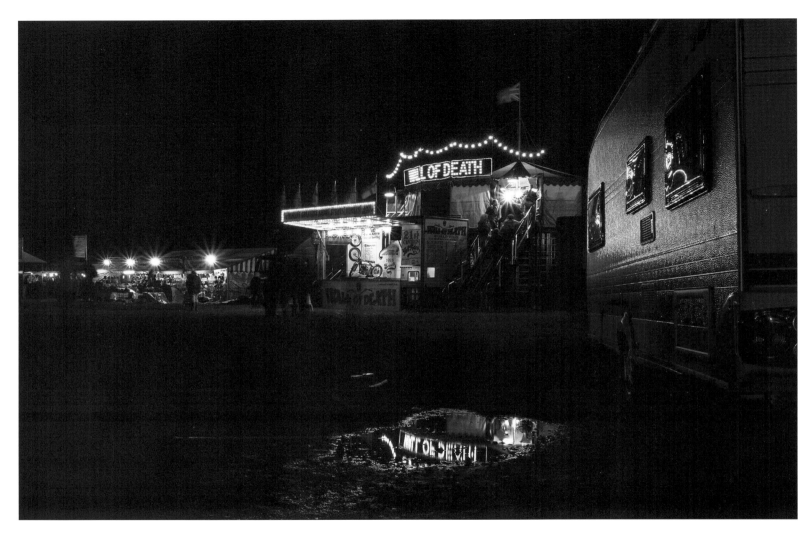

Bulldog Bash, 2010.

THE THUNDERING DRONE of the Indian motorcycle is clearly recognisable as you walk towards

the Wall of Death. The clatter from the wooden panels can be heard as the rider speeds around the wall, while the spieler invites you to attend the next show – a welcome invitation as it happens, as the English weather takes a turn for the worse.

The tilt acts like a giant umbrella protecting the customers from the sudden downpour. The Bulldog Bash is a regular destination for the Ken Fox troupe and a solid performance is always appreciated by the viewing crowd as the bar of the trick riding seems to be raised with every show. Alex is flying around the wall, riding as close to the safety cable as he dares! The Indian is carefully guided into its next trick. Relaxed and confident, Alex performs trick after trick, raising the eyebrows of many watching this young man perform. The crowds are four deep around the viewing area.

Each show has one demonstration of trick riding. Jaimi places a penny on a stack of coins next to the microphone making 17p in total (an easy way to remember that this will be the seventeenth show of the day). Ken kicks his Indian Scout into life; this bike seems a little louder as it sets off around the banking track. In a spilt second Ken is riding around the top of the wall, the Avon tyre being constantly pushed over the red line. This motorcycle is not being guided – it's being pushed to the limit with each trick. This is faster. The speed is insane; Ken flies up from the bottom of the wall almost vertically, the handlebars just inches away from the crowd, his boot clipping the safety cable. With a near-vertical drive Ken is riding around the base of the wall looking up for his next victim to shock! He accelerates straight to the top again to seek his prey, the speed more regulated for the next sequence. Ken throws his leg over the bike, maintaining his balance, he then places his feet on the inside footplate of the Indian, releasing his hands from the handlebars as the audience roar. He completes three revolutions standing on the footplate, arms raised. Ken uses his body to steer the Indian around the wall, shifting his weight to correct his line. He follows this act by placing his right foot on the leaf spring of the forks, perched on the fuel tank with his arms behind his back, smiling at the cheering crowd. As this performance nears its conclusion he is again riding around the wall at great speed, when suddenly, without warning, the frame on Ken's motorcycle snaps sending Ken into the wall, the wooden panels splintering under the force of the impact. Ken's down! The Indian screams, throttle stuck wide open. The inside of the wall quickly fills with smoke. Danny, Alex and Jaimi all rush over helping Ken to escape. The bike is lifted and the flames are out, Ken is standing, he looks up at the stunned crowed and walks calmly over to Alex's bike. Keeping his composure he forces his foot down on the kick-start, the engine starts, he rides around the wall to a deafening applause as he finishes his act even though Alex's Indian seems to shudder as it passes over the damaged pine panels. Ken pulls up alongside his damaged bike, winking at the riders present, his nerves unbroken.

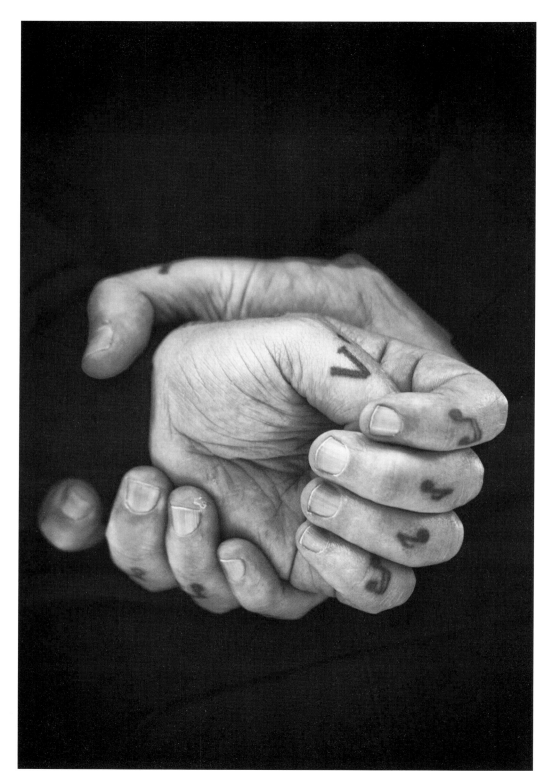

Danny's hands, 2010.

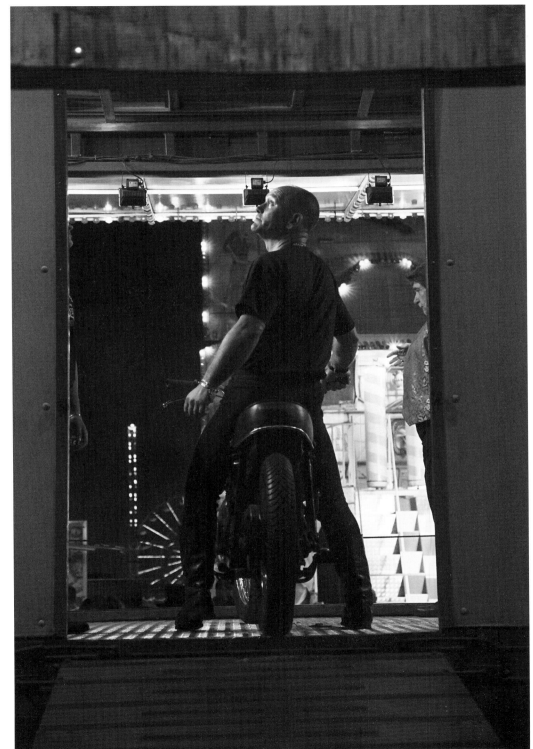

Ken Fox, Dorset, 2010.

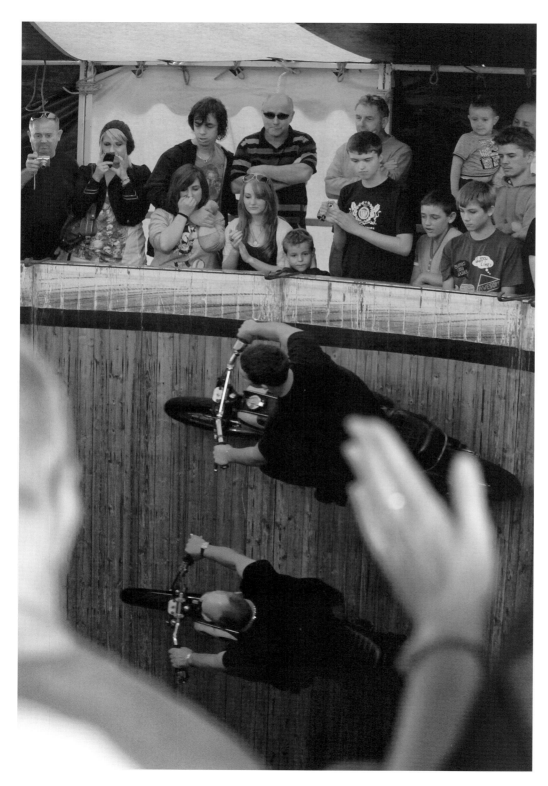

Alex and Ken Fox, Haddenham, 2010.

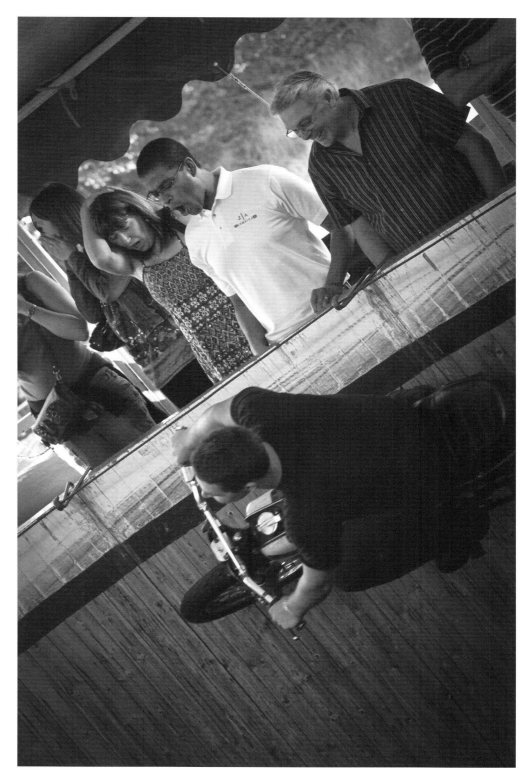

Alex Fox surprises the viewing crowd, 2010.

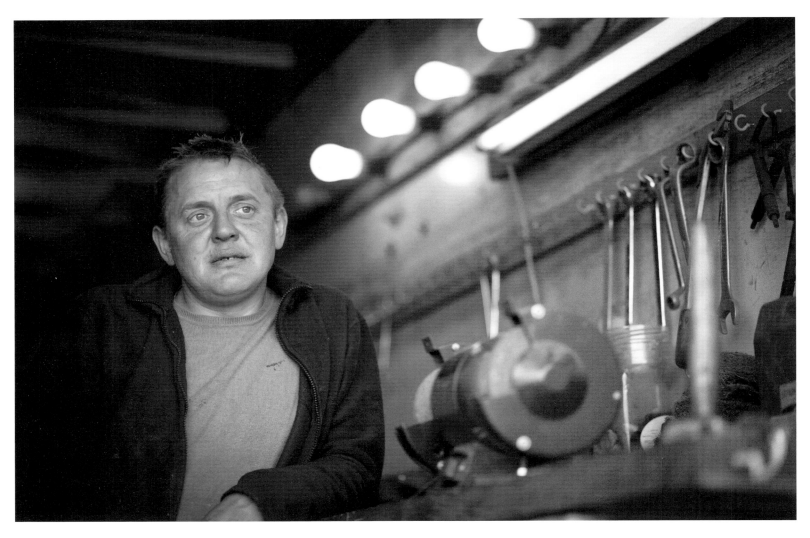

Lee, 2011.

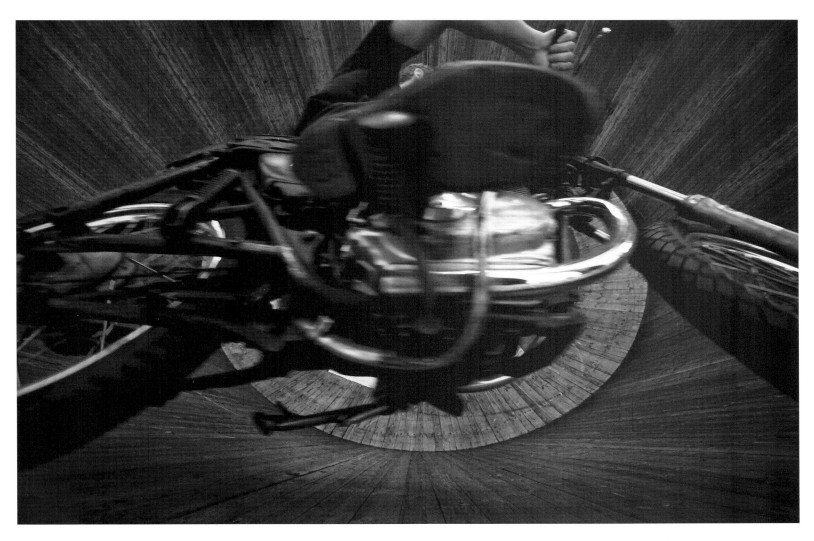

Luke Fox on the line during the three-man race, 2010.

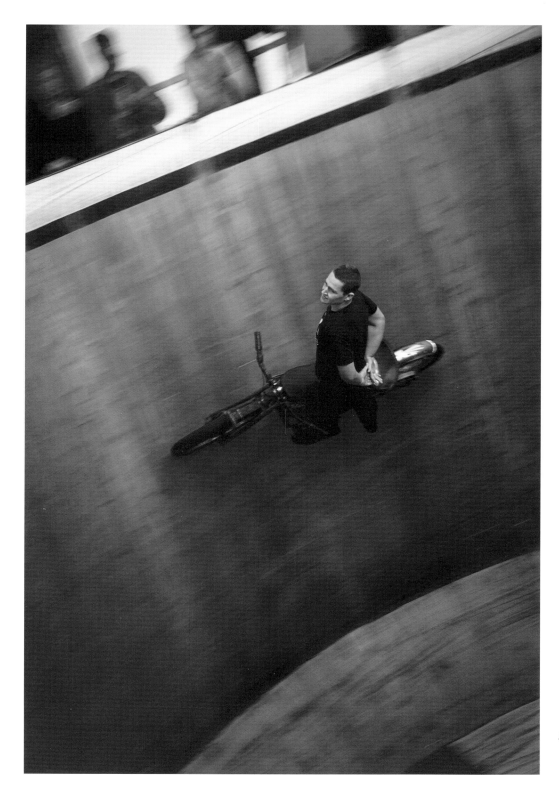

Alex Fox's first public side-stand, 2010.

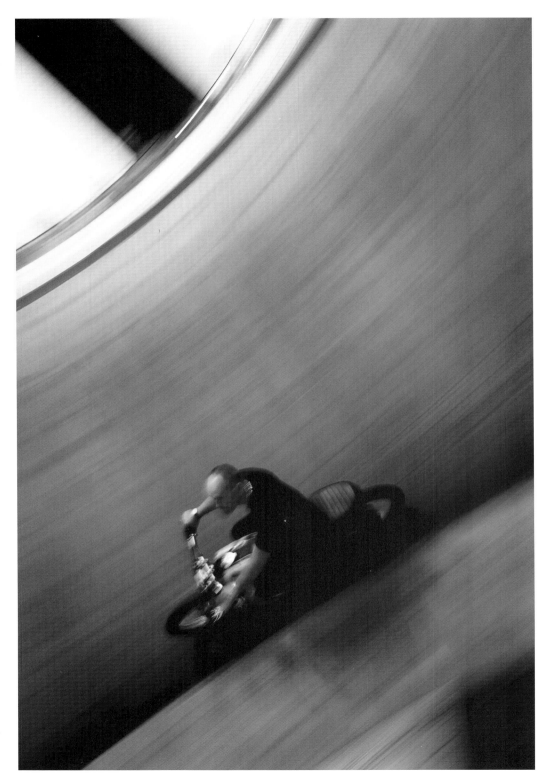

Ken Fox at speed, Croydon, 2010.

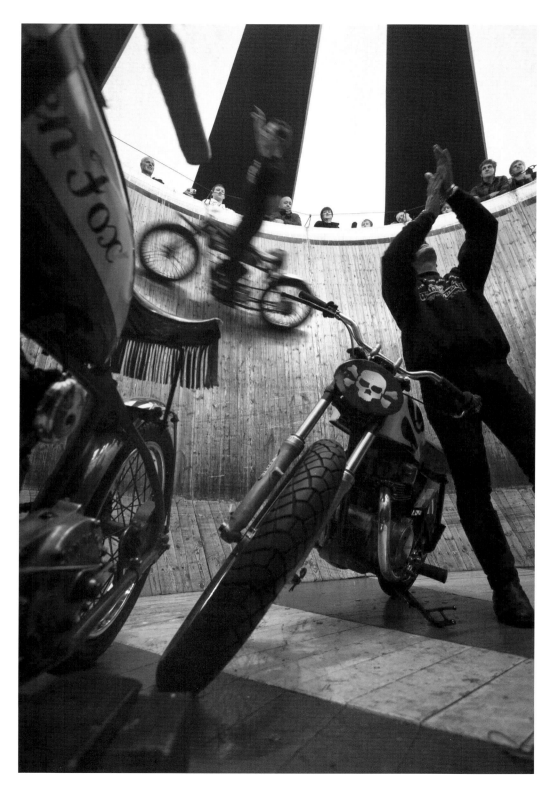

Alex and Ken, 2010.

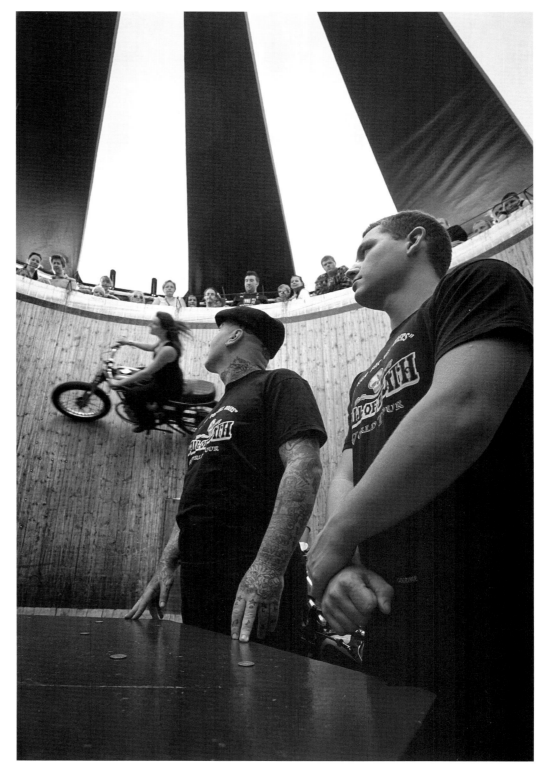

Danny and Alex watch Jaimi perform.

Ken Fox, Bulldog Bash, 2010.

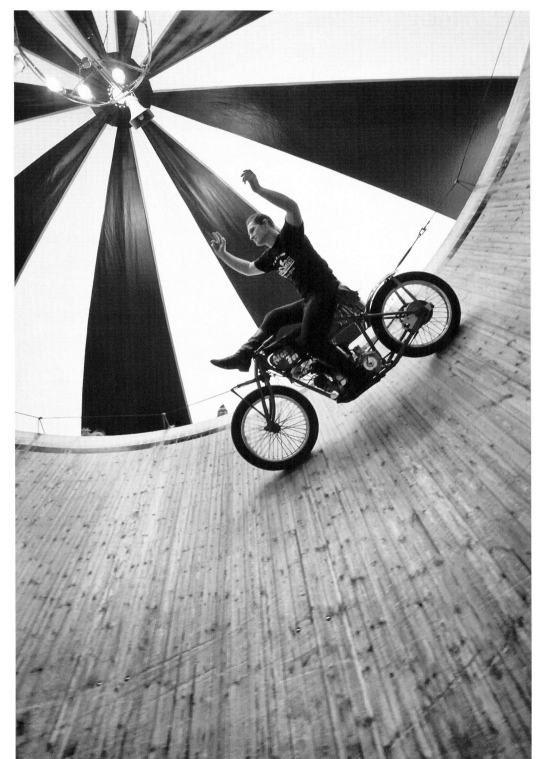

Alex, 2010.

Ken Fox, 2010.

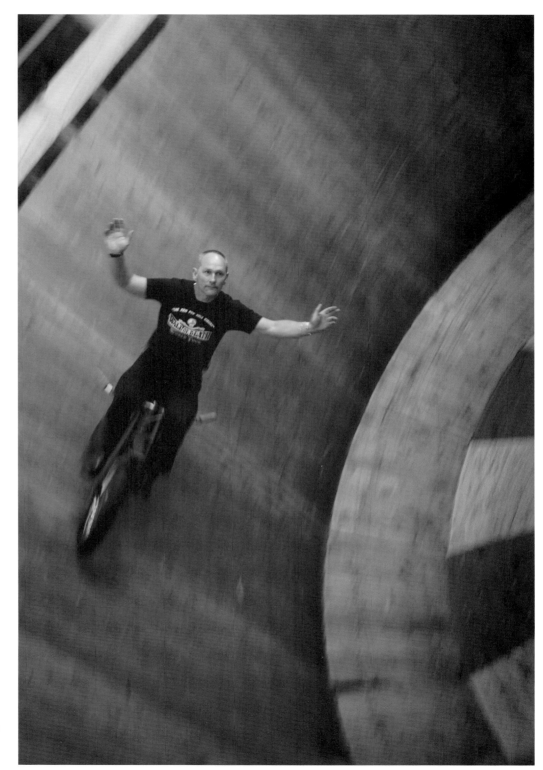

Ken keeps an eye on the line, 2010.

An ice cream seller listens to the spiel, Bulldog Bash, 2010.

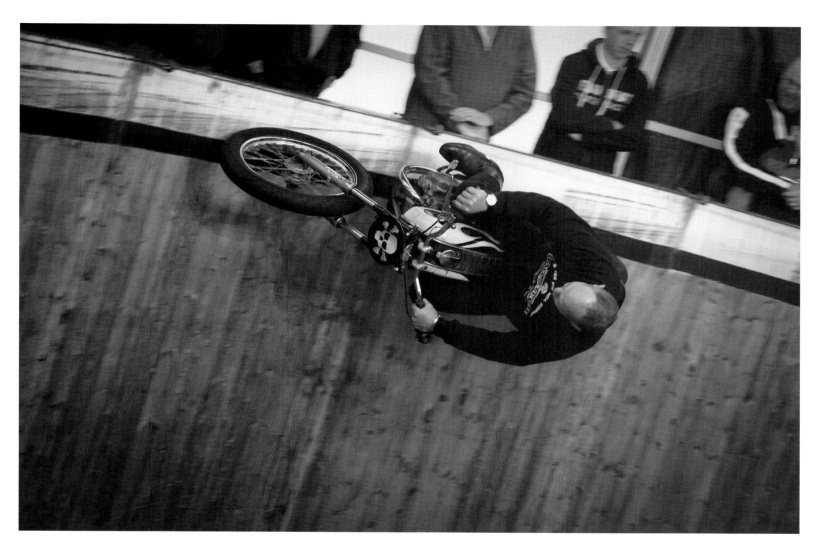

Ken's boot inches away from the safety cable, 2010.

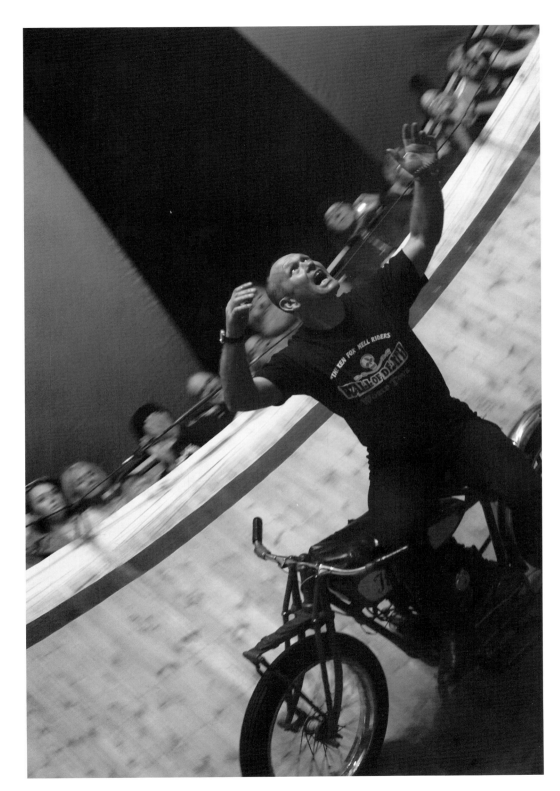

Ken Fox, 2010.

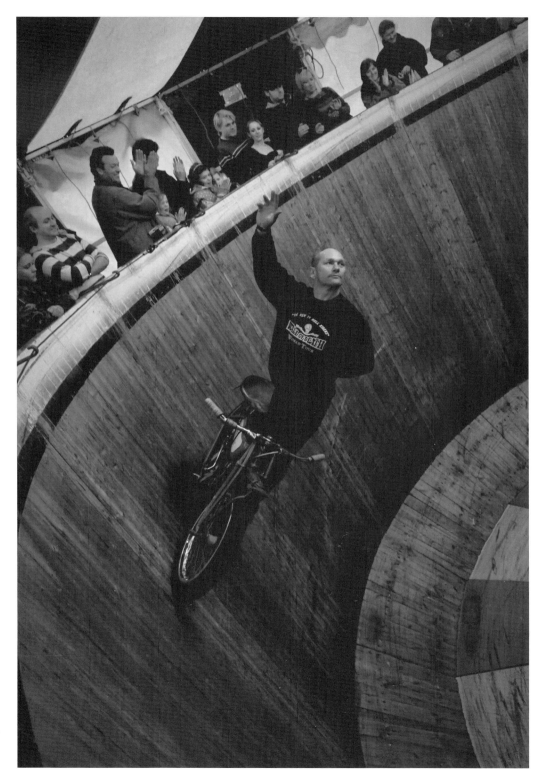

Ken Fox, 2010.

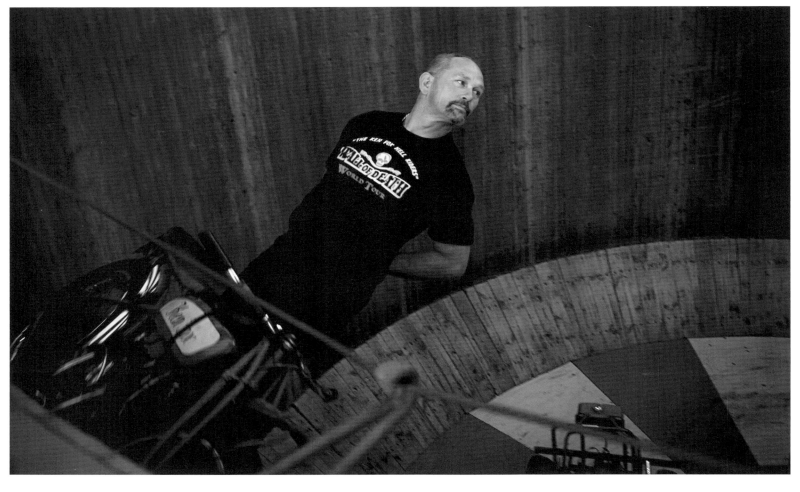

The showman – Ken Fox, 2011.

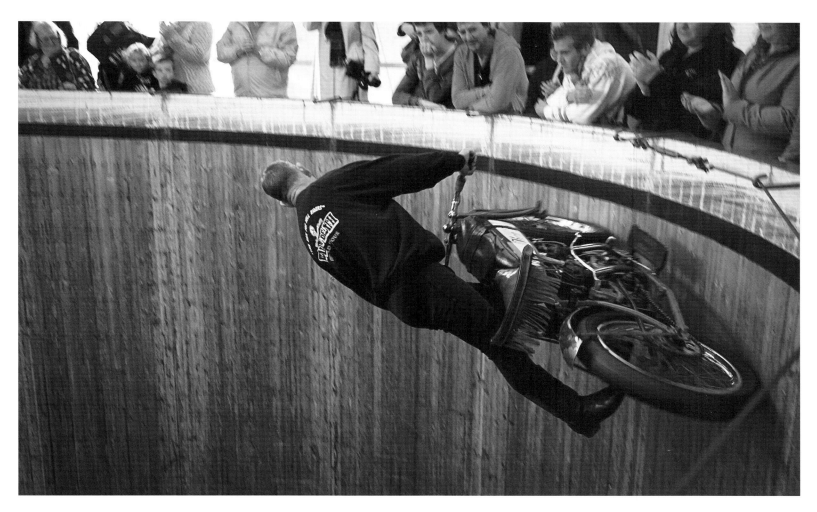

The start of Ken's trick-riding performance, 2011.

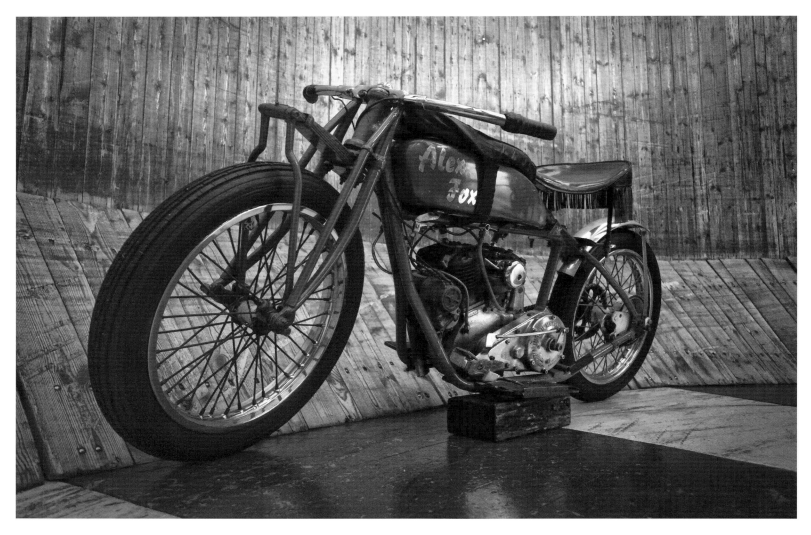

The Indian of Alex Fox.

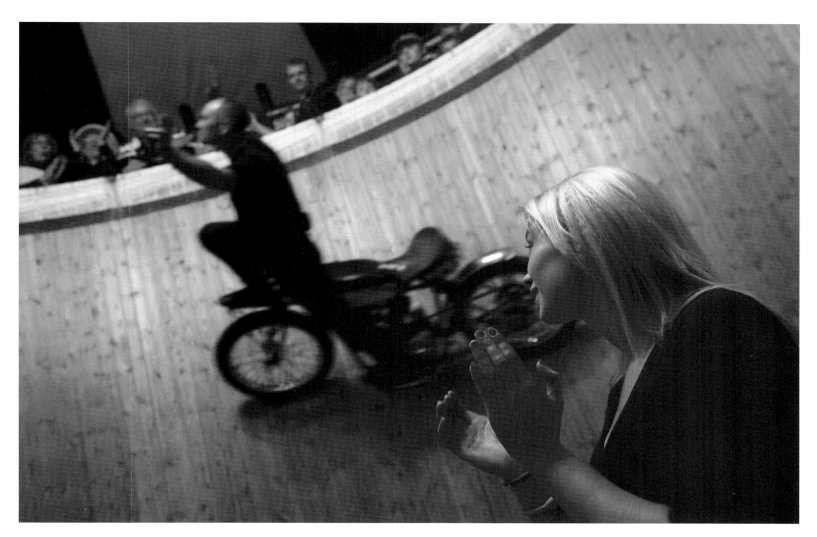

Ken Fox completes his performance, 2010.

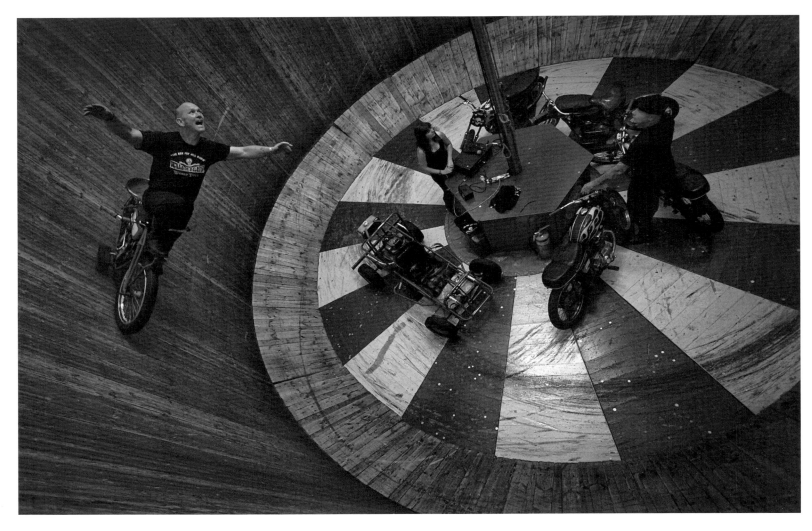

Moments later, Ken's frame snaps sending him into the wall.

SHOW'S END!

'Ladies and gentlemen, owing to the dangerous nature of this performance so far, no insurance company will insure the riders of these tracks against injury or serious accident.

Therefore, the management have kindly allowed us to a fund of our own. If you have appreciated the riding and would care to help towards this fund you may do so by throwing any donation you wish onto the centre of the floor. Thank you ladies and gentlemen, thank you one and all. If you have enjoyed our performance, please recommend us to your friends,

I thank you!'

Ken Fox

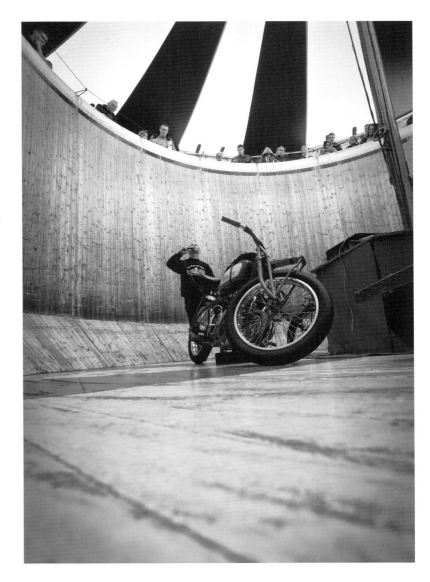

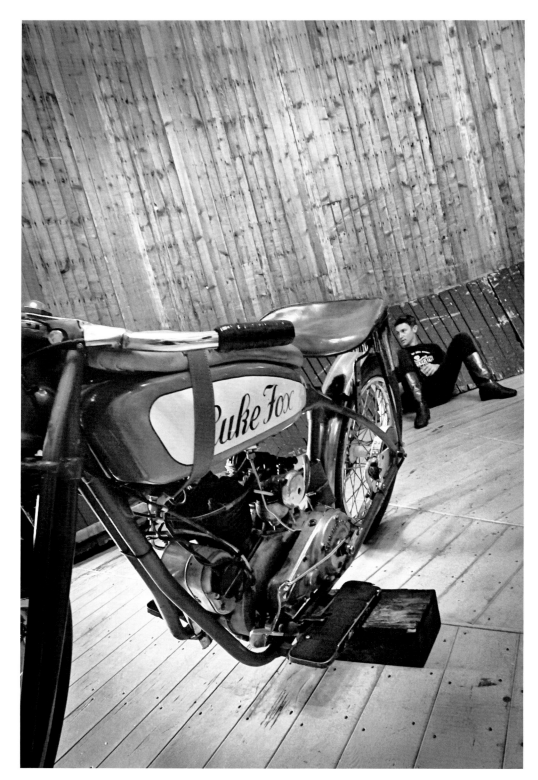

Luke taking a short break, 2010.

LUKE TAKES A BREAK before the last performance of the day while outside Neil Calladine entices the passing crowd with his spiel; this is briefly interrupted as Kerri starts the bally bike. The noise from the engine grabs the attention of the last few showgoers and they watch intently as Kerri starts to perform on the Indian motorcycle that runs on steel rollers on the bally; this is a static demonstration and gives a small insight of what's on offer inside the wall for real. Kerri performs a sequence of tricks while the crowd gathers in front of the wall. With an appetite to see more, the crowd make their way over to the box office and gather around the viewing area of this ageing wall. This is the original wall, also owned by the Fox troupe and operated by Ken's eldest son, Luke, during the busy summer schedule.

Constructed in the 1920s, a strong sense of history is present within the performance area. The wooden panels have witnessed many great riders over the years, when wizard performers amazed the crowds by regularly presenting a lion as part of their act. Waiting for the show to begin, the ghosts of the past can be visualised sweeping around the panels. Luke sits astride his Indian waiting for Ken Wolfe's act to finish, unaware of the drama unfolding on his father's wall. Luke's trick riding is swift and fast, a fitting tribute to the riders of a bygone era. Constantly performing trick after trick, Luke's act is seamless. As Luke descends, Ken Wolfe and Kerri are already aboard their Hondas.

The grand finale is the death race! This amazing spectacle combines riders racing around the wall, passing each other with just inches to spare, the thrilling full-throttle action concluding with spontaneous applause from the astounded crowd. They show their appreciation by dropping donations over the side to the floor below. The showgoers seem reluctant to leave but as they shuffle along to the exit they are complimented with thanks from the riders.

Luke picks up his phone noticing the missed calls that he has received, and walking around the wall he listens intently to the message unfolding concerning his father's accident. Luke calls his brother for an update, the wall is damaged but miraculously Ken is OK. Luke smiles; all around him the donations act as a constant reminder that he also cheats death with every performance. The brief sombre mood quickly lifts and the humour returns. A plan is hatched and the following day Luke and some of the crew will go over and assess the damage and help with the pull-down.

The early sun peers over the horizon as Luke makes his way over to see his father. On arrival everyone is up and already making a start. The usual humour keeps everyone in good sprits as they disassemble the wall. The splintered pine panels from the accident can clearly be recognised as they are placed into the lorry.

The damage to the motorcycle is revealed, and it becomes chillingly apparent that Ken was very lucky on this occasion. The smoke-stained Indian is removed from its natural surrounds and placed in a van to be taken for repair.

Kerri performing on the bally bike, 2010.

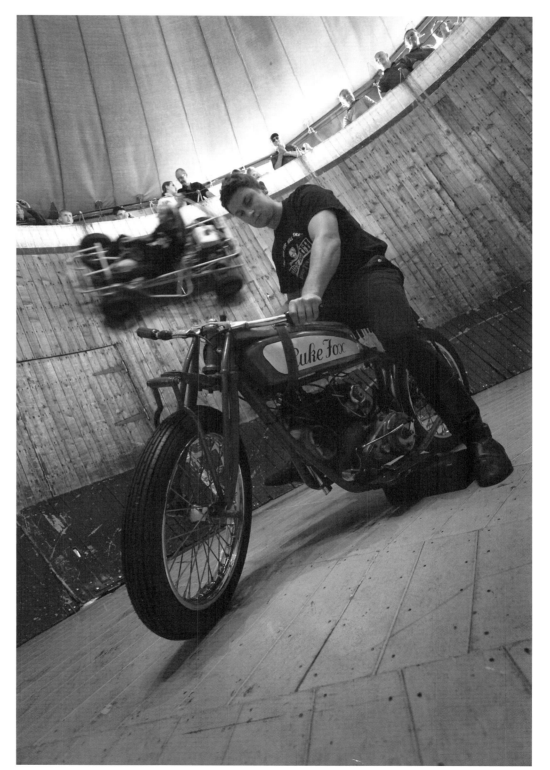

Luke Fox, 2010.

Only the brave, 2010.

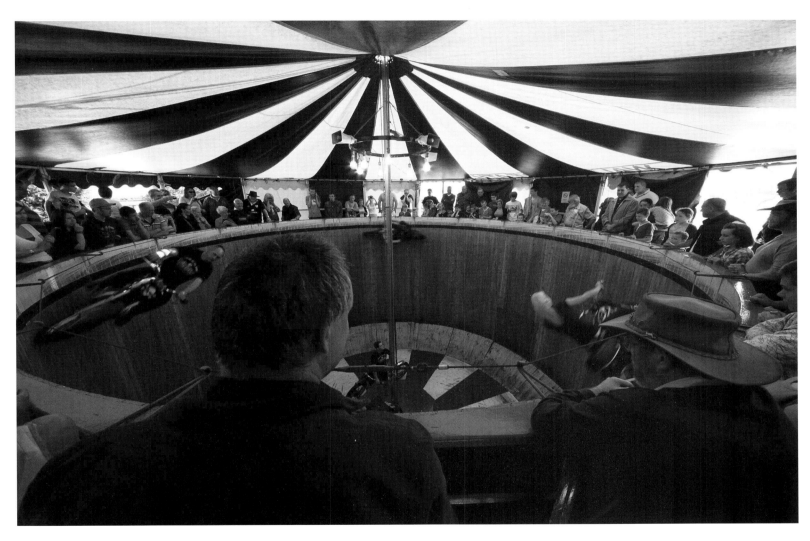

Haddenham Steam Rally, Cambridgeshire, 2010.

Shadow of a rider, 2011.

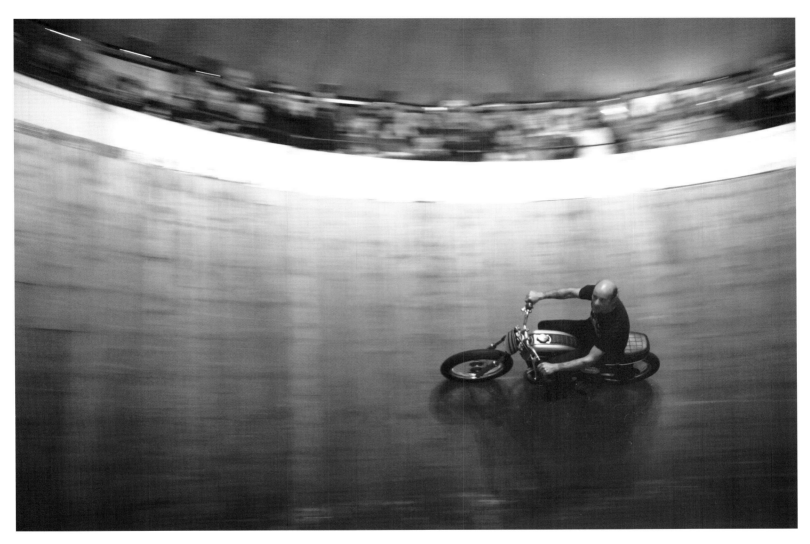

Ken Wolfe, Ipswich, 2010.

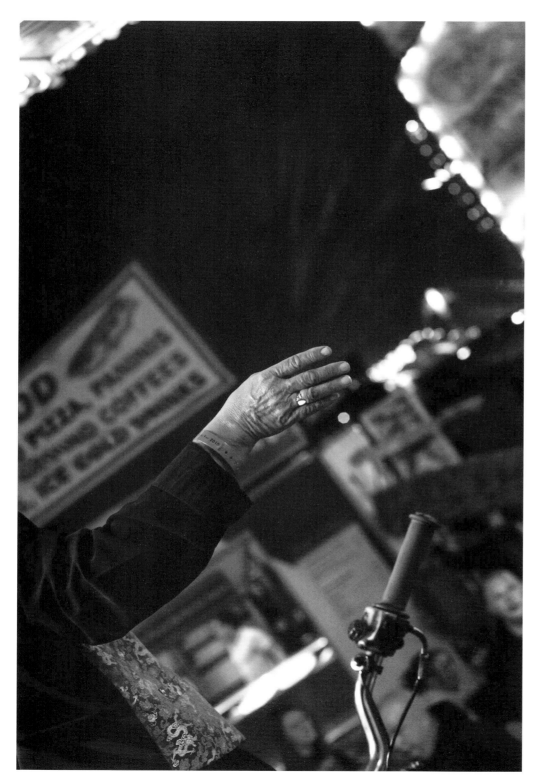

The spieler, 2010.

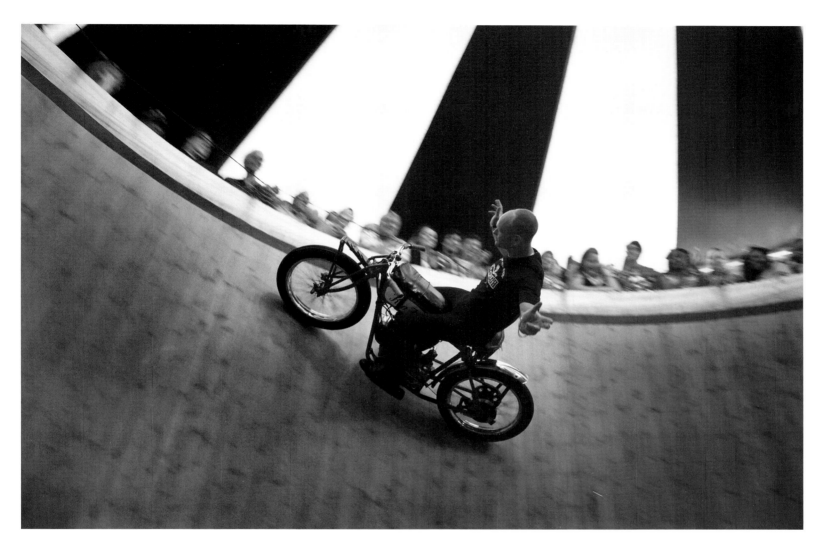

Ken Fox going for the line, 2010.

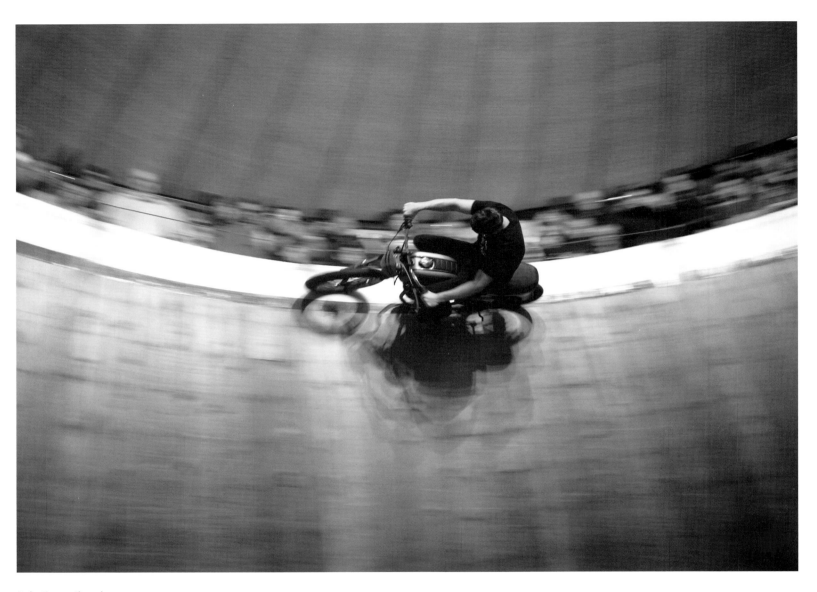

Luke Fox on the edge, 2010.

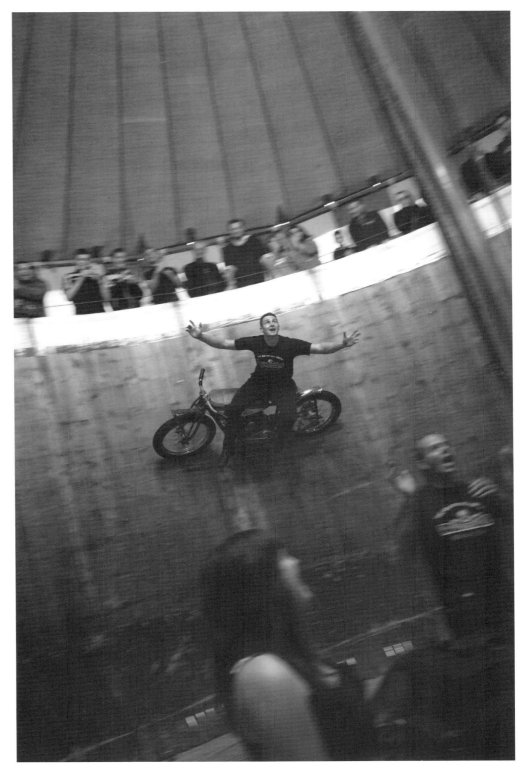

Luke Fox, 2010.

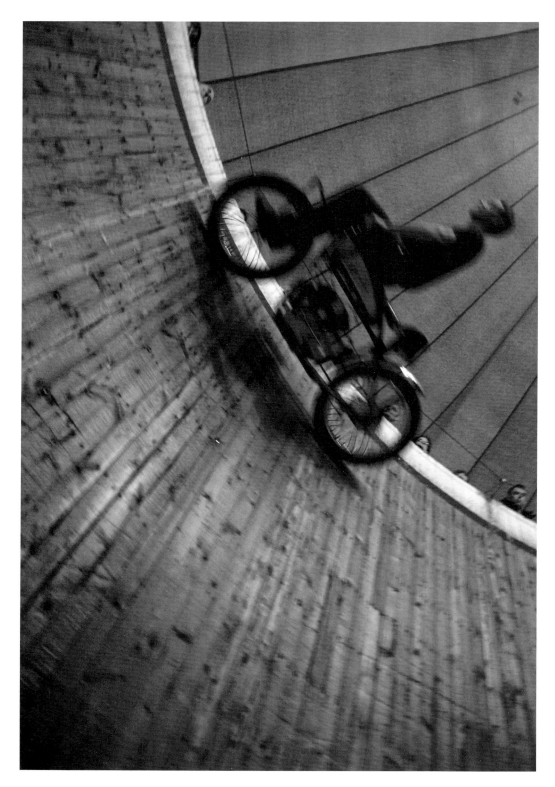

Luke Fox gliding around the ageing wall, 2010.

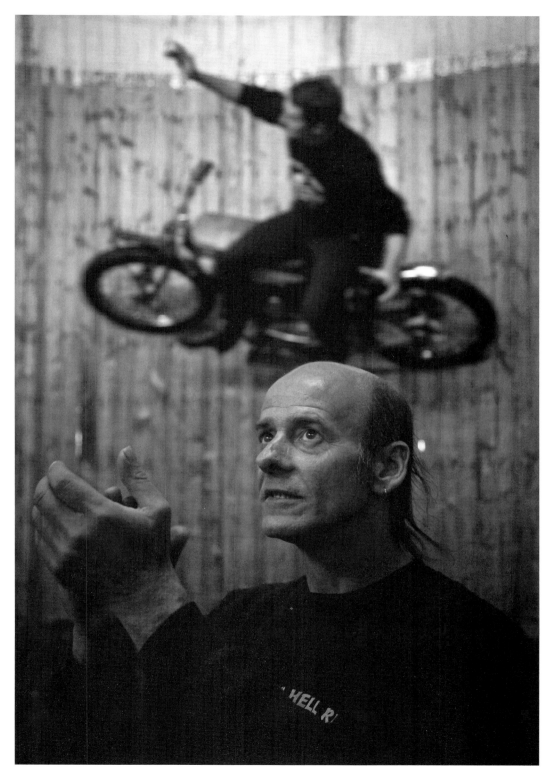

Ken Wolfe and Luke Fox, 2010.

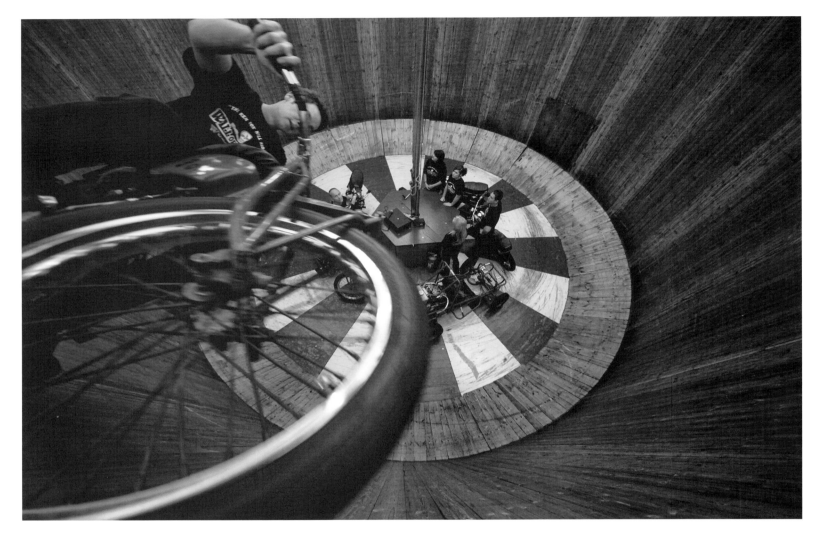

Luke Fox hits the top during the dips and dives routine, 2010.

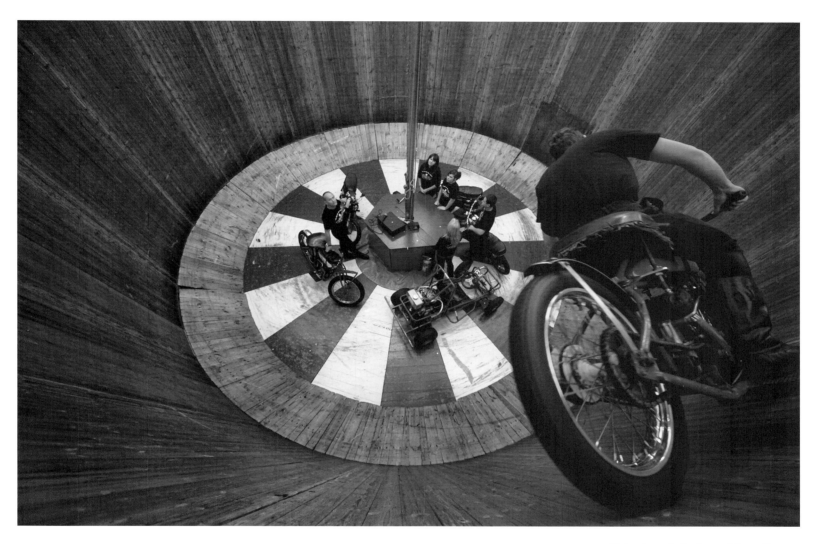

Diving towards the base of the wall, 2010.

Reflection of the three-man race, Ipswich, 2010.

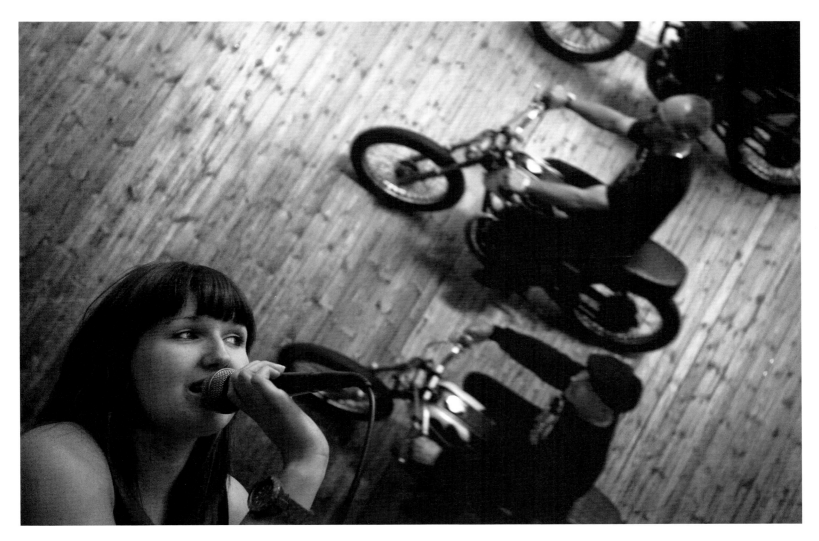

Jaimi announces the riders during the death race, 2010.

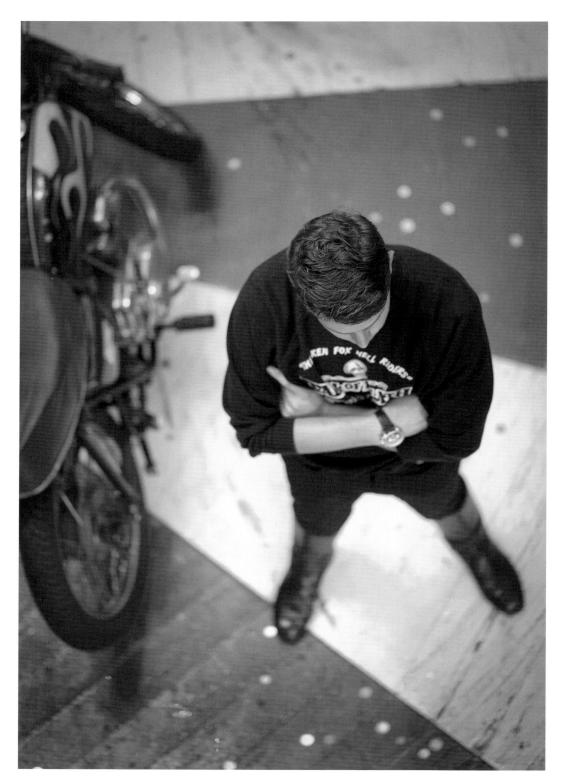

Luke Fox, 2011.

Luke Fox on his way to see his father on the morning after the accident, 2010.

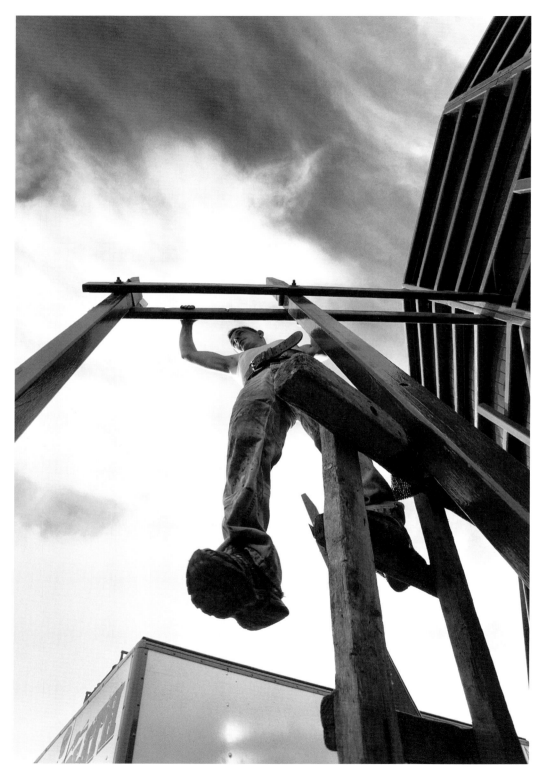

Willie starts the pull-down, 2010.

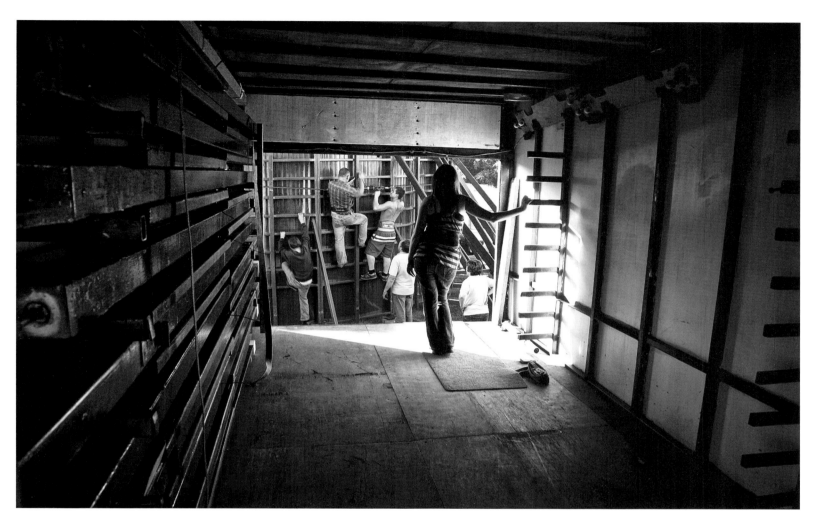

Everyone lends a hand, 2010.

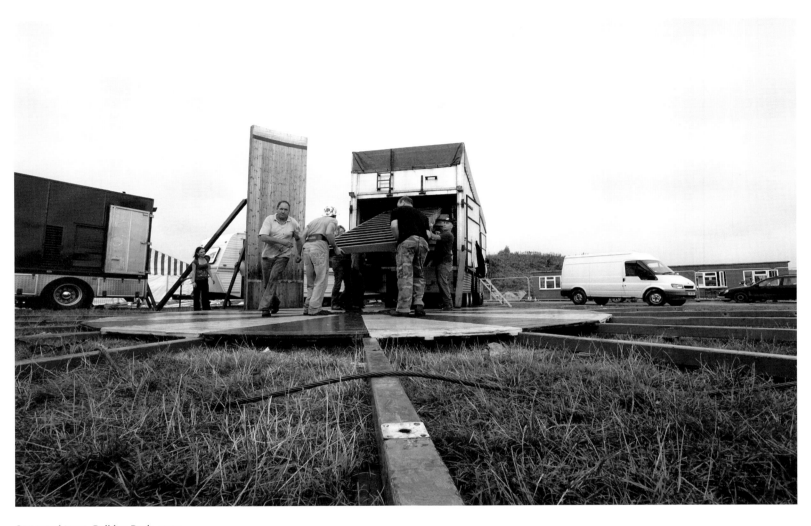

One panel to go, Bulldog Bash, 2010.

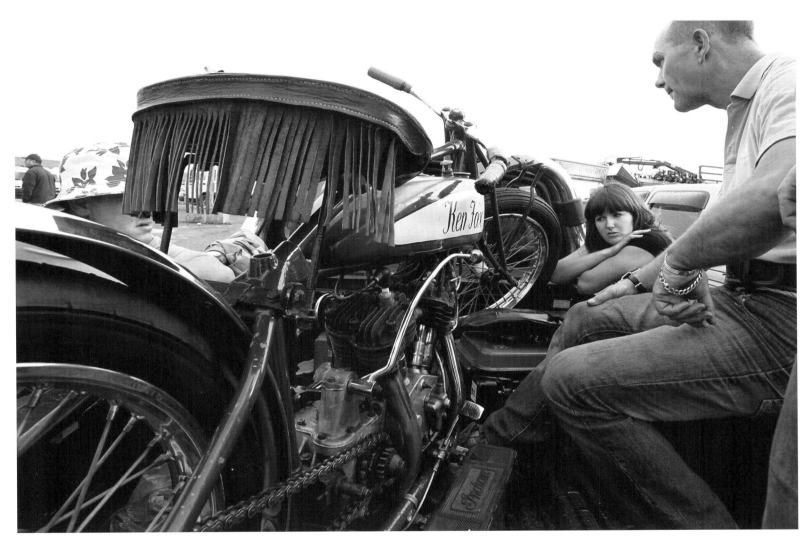

Ken's damaged Indian, Bulldog Bash, 2010.

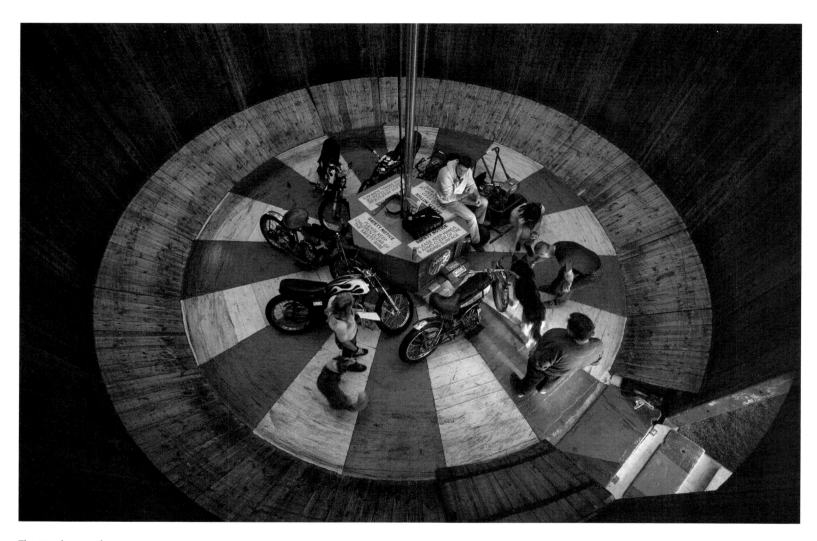

The morning meeting, 2009.

THE EARLY MORNING SCHEDULE

normally starts with a meeting over a cup of tea within the wall. The fitness and welfare of all the riders and crew are paramount; this is also a time of refection, a time to master a new trick ride, a time for improvement and repair. It's not solely during the winter months that essential maintenance work needs to be carried out. Alex drains his beloved Indian ready for an oil change. Jaimi walks around the top of the wall scanning the pine panels for any large splinters or loose nails which may become a hazard to the riders during the show. The bikes are refuelled and the tyre pressures corrected. The motorcycles are started and taken up onto the wall; the awakening of the wall has started and the first performance is just hours away. The handling on the recently repaired Indian is different this morning and instantly Ken realises that something is not right. He carefully rides the bike back to the floor and after a close inspection, it becomes apparent that the front tyre will need replacing. As Ken sources a new tyre the hands on the clock are set to 11.00 a.m. for the first performance. The expectation builds throughout the morning schedule.

Is the weather going to hold today? Will the attendance be up from last year? Ken's thoughts of running this show are briefly interrupted as Freebie and Jinks (the family's dogs) calmly swagger into the inside of the wall and watch him replace the damaged tyre, their only contribution being an encouraging wag of their tails. The handrails are cleaned and the stairs are swept in anticipation of a new audience. The tyre is now on. And all before breakfast!

Another morning is coming to a close, another series of performances are just about to begin, the surroundings have changed along with the faces, but the wall remains the same. The riders polish their boots, the last detail before they present themselves in front of the new, excited crowd. The spieler announces the riders as they walk up onto the bally. Step right up, the show once more is under way! The crowds are building and once again the skill of the riders will be tested. Tomorrow a new destination, but for the twenty-first-century hell riders it is just another day!

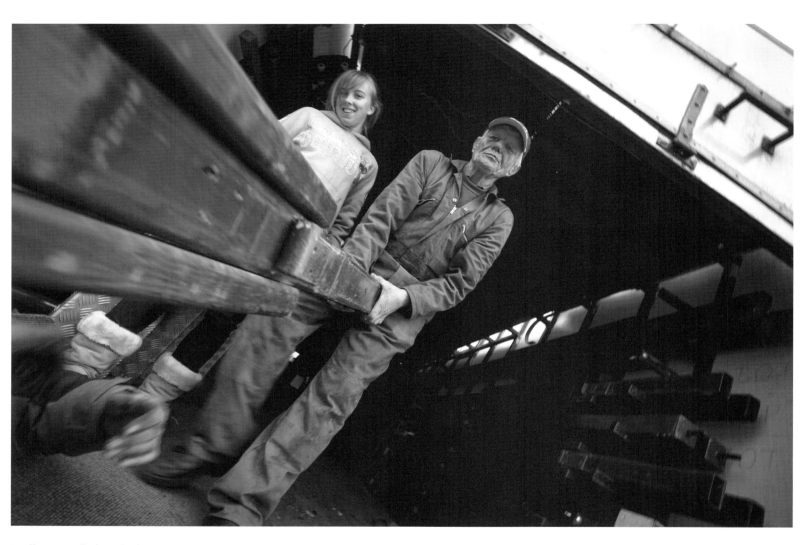

Loading up! Wall of Death winter quarters, 2009.

Pickering, 2010.

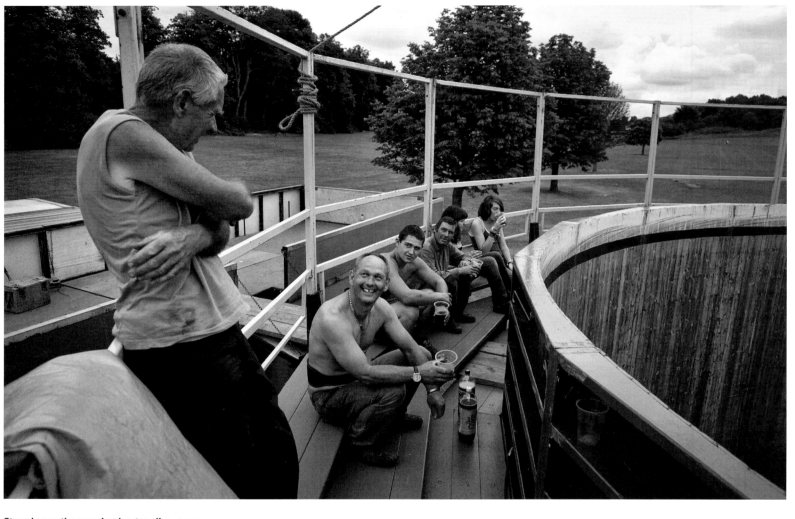

Steve keeps the morning banter alive, 2010.

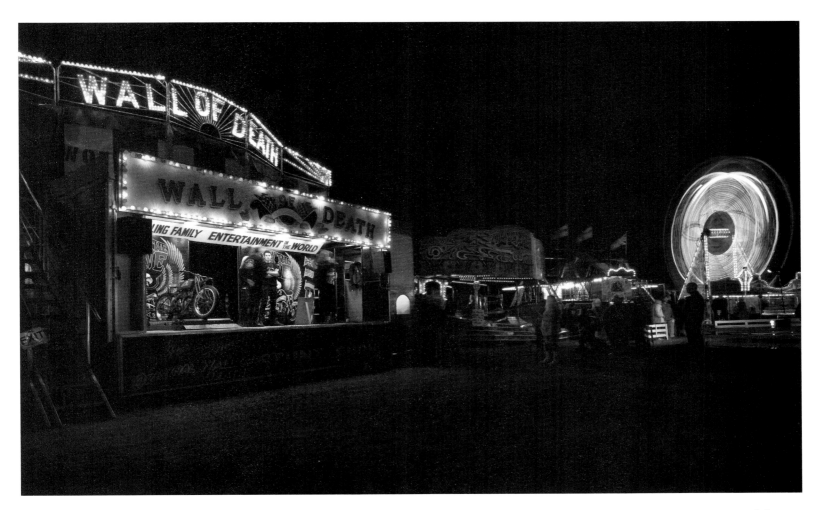

Norfolk, 2010.

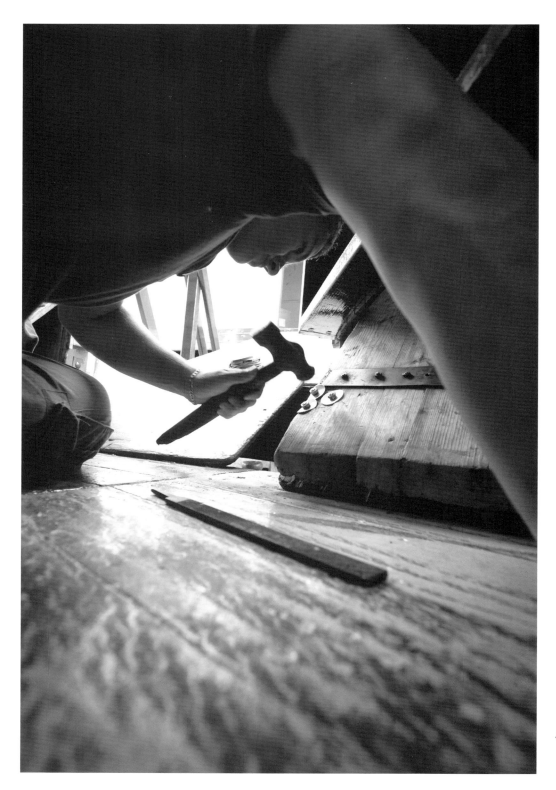

Alex Fox makes morning repairs, 2010.

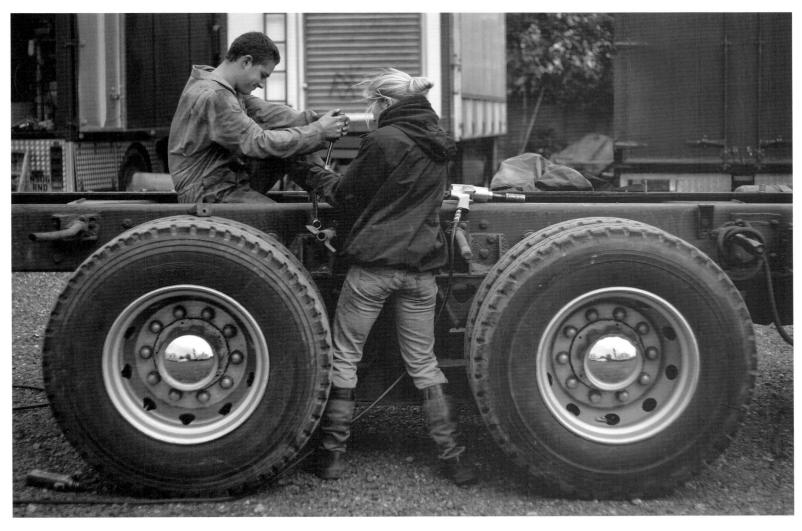

Alex and Kerri tackle one of the bigger winter jobs, 2010.

First light, 2010.

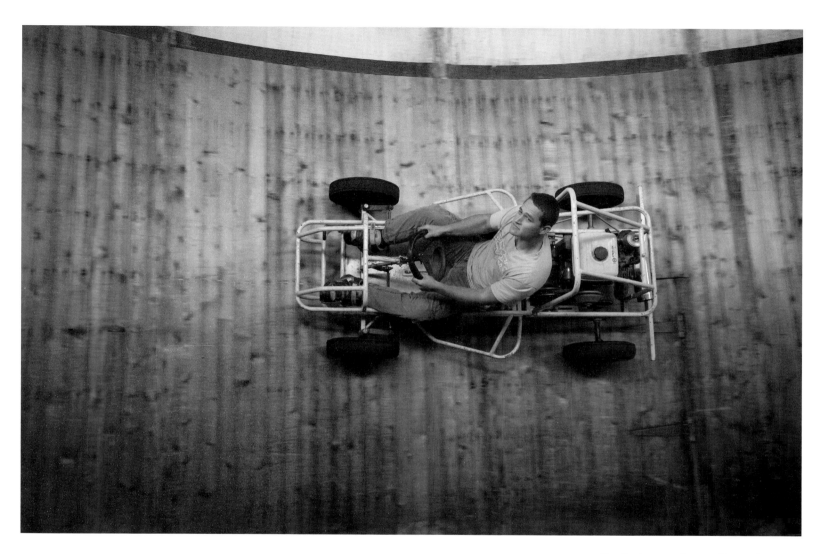

Alex Fox in a morning practice session, 2010.

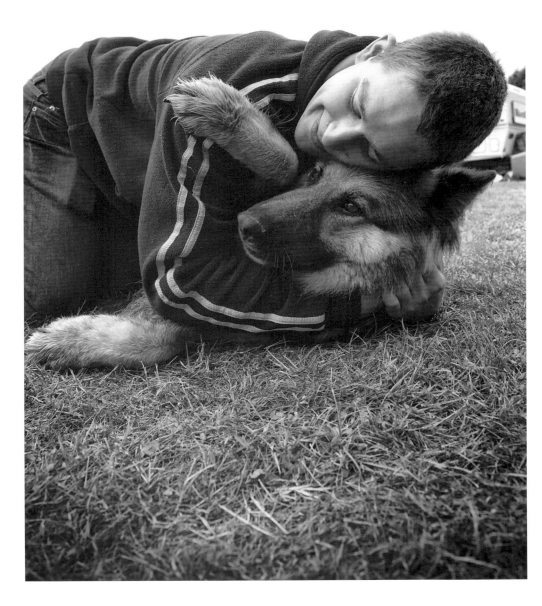

Alex and Jinks at the Royal Cornwall Show, 2010.

An approaching Indian, 2011.

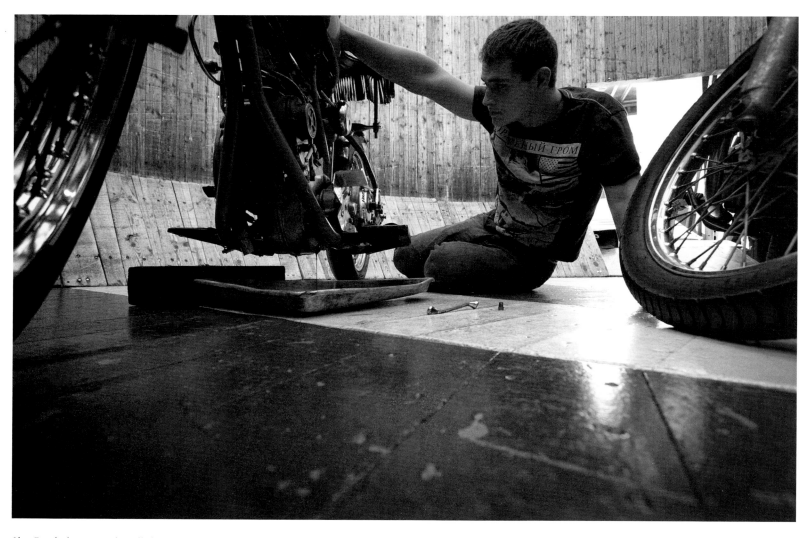

Alex Fox during a morning oil change, 2010.

Alex, Guildford, 2010.

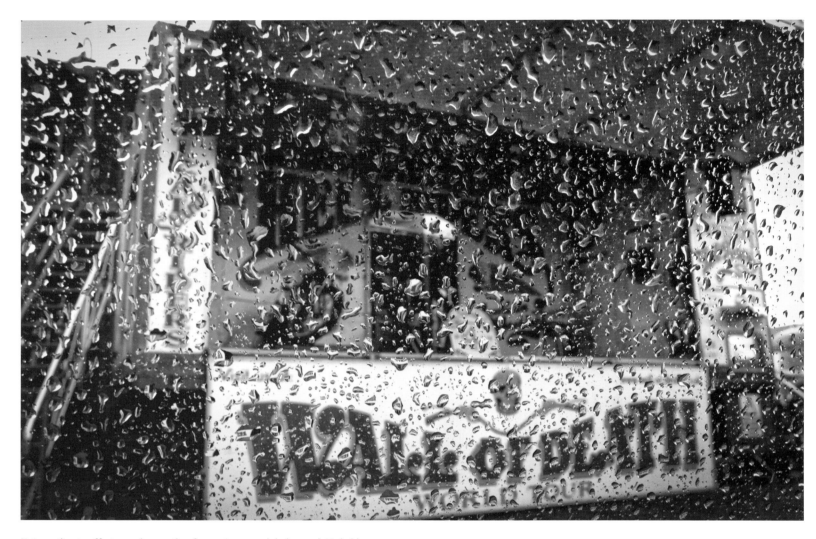

Not wanting to affect morale, weather forecasts are mainly ignored, Yorkshire, 2010.

Jinks, Yorkshire, 2010.

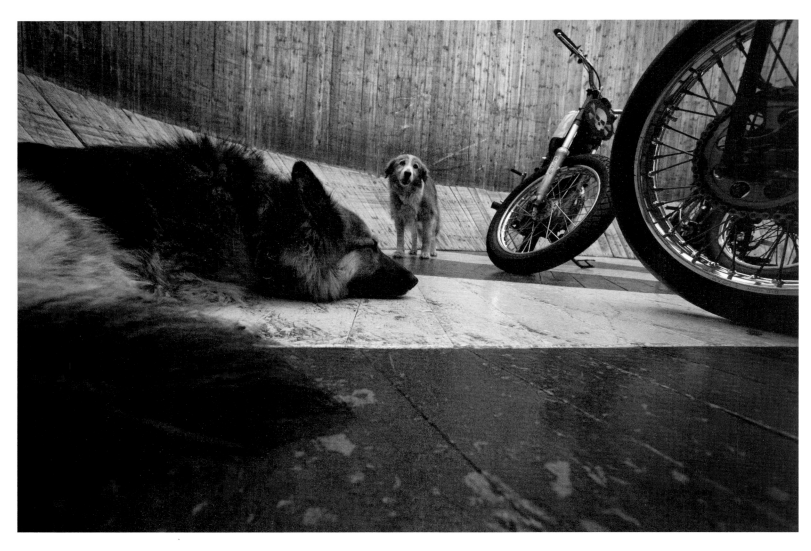

Freebie and Jinks, Dorset, 2010.

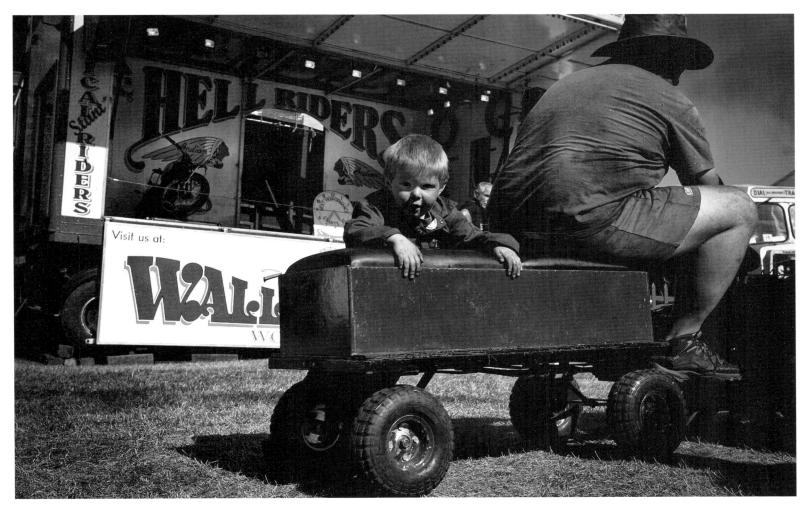

Kent County Show, 2010.

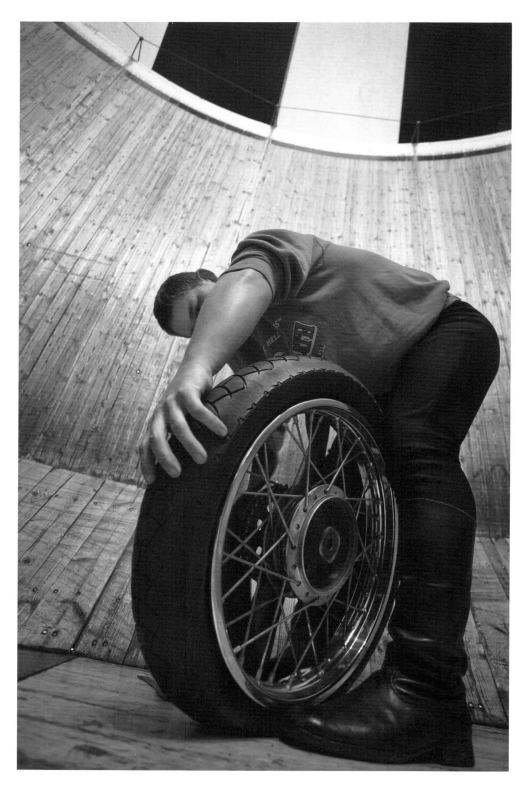

Alex replacing a tyre, Lincoln, 2009.

Alex prepares for the first show, 2010.

Alex Fox, Pickering, 2010.

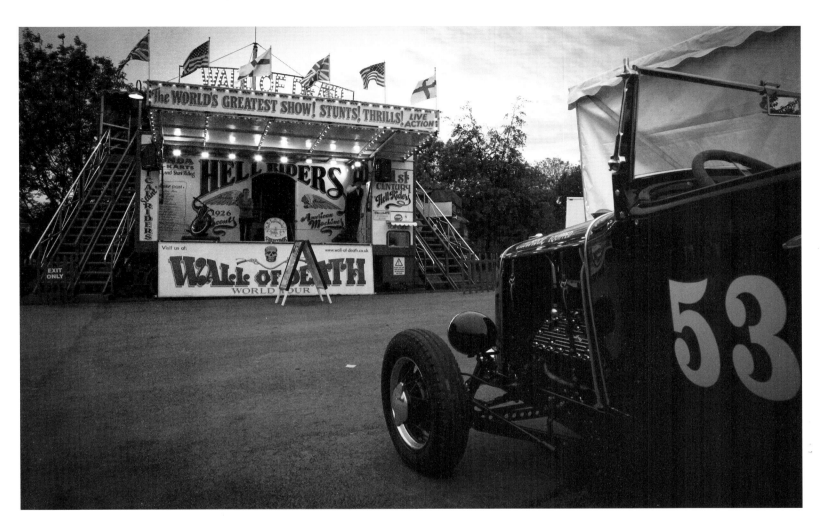

Prescott Hill Climb, 2010.

Pickering, 2010.

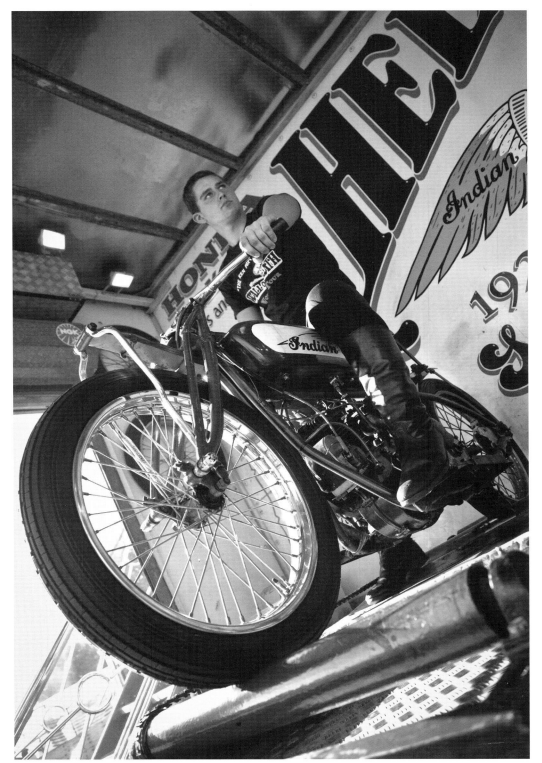

Alex Fox, 2010.

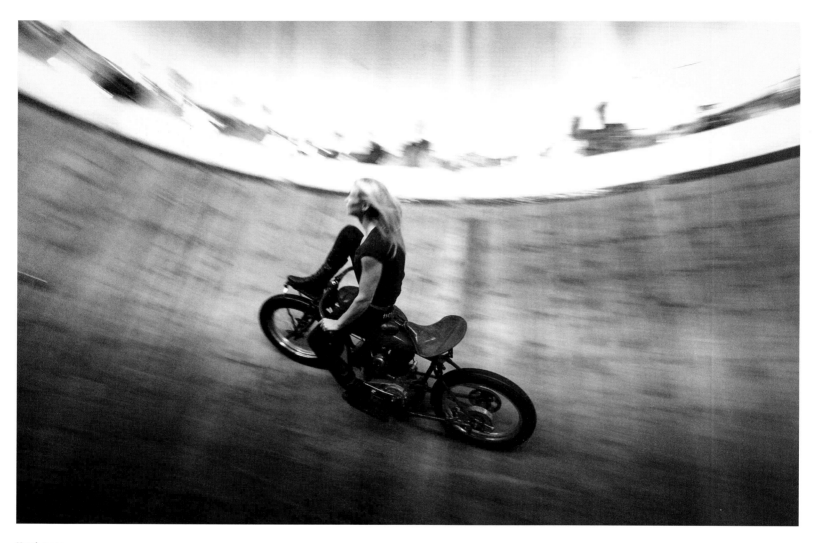

Kerri, 2010.

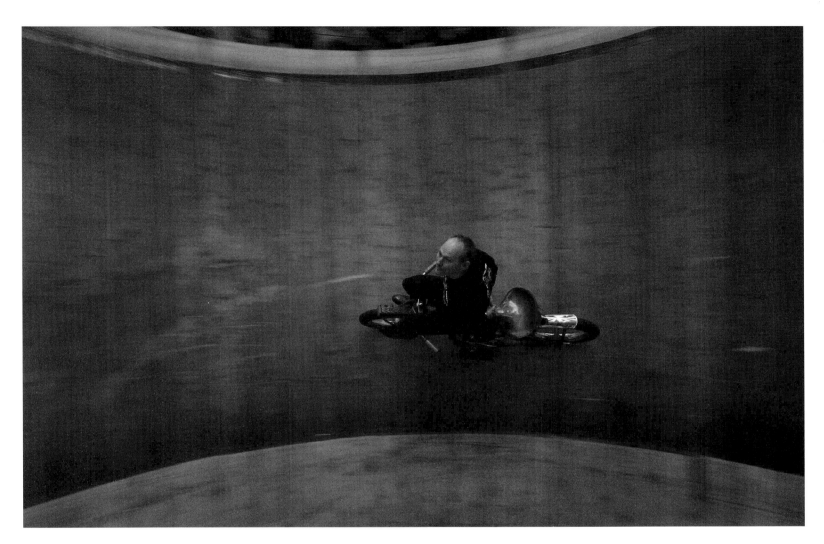

Ken Fox, 2010.

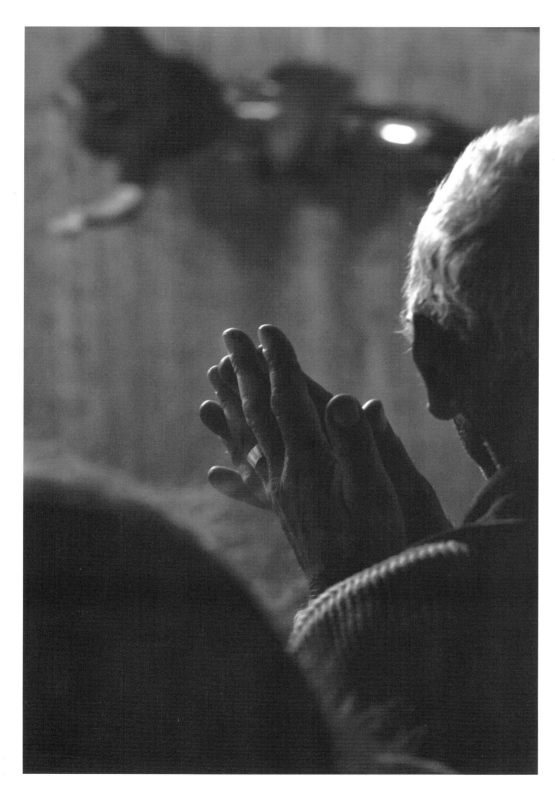

Great Dorset Steam Fair, 2010.

EPILOGUE

I first encountered the Ken Fox troupe in early 2009. I was astonished by the wonderful spectacle that is the Wall of Death. The vintage bright red Indian motorcycles and smartly turned out riders seem to perform a feat from the past before the eyes of a modern world. I wanted to capture this astonishing life with photography and set out to document the lives of Ken and his wonderful family.

This book is a brief glimpse of the twenty-first-century hell riders over a typical season as they travel the length of the British Isles, incorporating the atmosphere and characters of each show. Using only the available light, and with minimal post-editing consisting of a simple black and white conversion for my images, I wanted to keep this publication genuine.

For some people, watching a rider risk their life for a good performance can become a very emotional experience. For others it's an exciting, all-consuming thrill. Either way, the memories absorbed during a performance from the Ken Fox troupe will remain vibrant in your mind. There is always a healthy thread of humour that runs though this family making this daring, dangerous and demanding profession seem almost relaxed.

This is a personal book about my time with Ken Fox's Wall of Death, which I photographed between 2009 and 2011. The text is from scribbles and notes made throughout the year and flashbacks from my memory.

The Wall of Death is a way of life. The showmanship and tradition of this unique culture is kept alive by Ken and his dedicated, professional team. They are constantly improving and maintaining all aspects of this travelling spectacle. If the previous pages have aroused your curiosity then go and see the Wall of Death for yourself, you will be transfixed by the amazing skill of the twenty-first-century hell riders as they ascend the vertical wall.

Gary Margerum, 2012
garymargerum@gmail.com